The Campus History Series

THE SCHOOL OF THE ART INSTITUTE OF CHICAGO

The Campus History Series

THE SCHOOL OF THE ART INSTITUTE OF CHICAGO

THOMAS C. BUECHELE AND NICHOLAS C. LOWE

ARCADIA
PUBLISHING

Published by Arcadia Publishing
Charleston, South Carolina

Printed in the United States of America

Library of Congress Control Number: 2016955360

For all general information, please contact Arcadia Publishing:
Telephone 843-853-2070
Fax 843-853-0044
E-mail sales@arcadiapublishing.com
For customer service and orders:
Toll-Free 1-888-313-2665

Visit us on the Internet at www.arcadiapublishing.com

CONTENTS

ACKNOWLEDGMENTS

The largest part of the material included in this book has come from our own institutional archives, a record that reflects the life of the organization back to the Great Chicago Fire of 1871. Maintaining an institutional record and collection of this stature can only be achieved through the ongoing commitment and support of numerous undocumented archivists and librarians. We are grateful to them all; our deepest thanks go to the present archivist, Bart Ryckbosch, whose knowledge and insights have extended our understanding of the materials immeasurably. Ryckbosch has been our constant supporter and collaborator, delivering materials and scans to us on very short notice. He is to be acknowledged as much an author of this book as we are.

For their collaboration, we also want to sincerely thank Jes Standefer and Shang-Huei Liang for their constant support, input, and additional brainpower. Their management of detailed information as work progressed has been irreplaceable. We would like to additionally credit Shang-Huei Liang for her support in image processing, sorting, and editing. An invaluable sense of context and enthusiasm for the archives was provided by numerous alumni, staff, and faculty—most notably Felice Dublon, Tom and Stella Kapsalis, and Jim Zanzi. Our colleagues throughout the school have expressed great interest in our work, and of those who have been attentive to our questions, we would most like to thank Claire Eike, Scott Hendrickson, Mark Jeffery, Kitty Ross, Lisa Stone, and Ann Sullivan; their advice and insights have been matchless.

The delivery of content to print requires very specific digital skill sets and technical support, some of which we do well and much of which was ably facilitated by Chris Day from our digital archives and libraries, alongside Alan Labb and Andrew Jones.

Searching for details outside of our archives began over two years ago, and we were informed and distracted by incredible materials and content, much of which never made it into this publication. For the pointers and access in the Mineral Point Archive Wisconsin, we would like to thank Nancy Pfotenhauer and Barbara Polizzi, and for a remarkable weekend on the Shake Rag, many thanks go to Jim Stroshein. Thanks also go to Christopher Hommerding for sharing aspects of his PhD work.

Unless otherwise noted, all images appear courtesy of the Institutional Archives of the Art Institute of Chicago. Additional images in this volume appear courtesy of the sources listed below; abbreviations are included in the relevant captions:

Chicago History Museum (CHM)
Chicago Tribune (CT)
La fondation Daniel Langlois (FDL)
Hedrich Blessing Photographers (HBP)
Kirk Gittings Photography (KGP)
The J. Paul Getty Museum (JPGM)
Library of Congress (LC)
Mineral Point Archives (MPA)
Newbery Library (NL)
New York Public Library (NYPL)
New York Times (NYT)
The Sangamon Valley Collection at Lincoln Library (SVCLL)
University of Illinois Archives (UIA)
White House Historical Association (WHHA)

INTRODUCTION

In 1866, Chicago was a city in process. Occupying just over 16 square miles of the Lake Michigan shoreline is a narrow strip around two miles deep running from east to west, barely touching the prairie. The city was either perched or floating upon a land that is described by James Parton as "no longer a quagmire." Parton, in his article "Chicago" for the March 1867 *Atlantic Monthly*, goes on to outline how the city, its institutions, and its people have risen to rival any other American city at that time.

All boosterism aside, the indicators of such stability and the ongoing ascendancy of the city make for an impressive litany of facts, figures, and descriptions—not least to apprehend the atmosphere of the time that gave birth to the School of the Art Institute of Chicago (SAIC), when the great passions and terrible losses of the Civil War were still being so very keenly felt. The tastes of people in Chicago were as equally for the virtuosity of the violinist and the painter as they were for the daily movement of stock and goods. All speaks to a city seeking to draw its inspirations as much from the arts and culture as from commerce and industry.

The origin of SAIC can be traced back to November 1866, when 35 local artists met at Reynold's Block on Dearborn and Madison Streets and the Chicago Academy of Design took form. Academy members intended to institute a free school of "life" and "antique" drawing and to run a gallery that would sponsor literary, musical, and dramatic events. On May 3, 1867, the academy held its first event in Crosby's Opera House. Later that year, under a revised constitution, Leonard Wells Volk was appointed to act as president, and a curriculum modeled in the French academic manner was instituted early in 1868. In 1870, the academy moved into its own building for the first time, only to be destroyed in 1871 by the Great Chicago Fire. Following this obvious setback, the academy again struggled to find a home, though by 1874, it was fully up and running once again, in rented rooms on the southwest corner of Michigan Avenue and Van Buren Street.

Then, following another move in 1877, further financial support was called for and received in 1878 through the addition of benefactors in the form of a board of trustees. In 1879, the artists and the benefactors were at odds over the management of the academy and a further reorganization took place. Finally, a new institution was born: the Chicago Academy of Fine Arts. This new entity assumed the same facilities with the same students, faculty, and staff. In fact, as a report in the *Chicago Tribune* on June 29, 1879, points out, not a day was missed and classes continued uninterrupted into the summer. In 1882, the Chicago Academy of Fine Arts changed its name to the Art Institute of Chicago, and then by extension, the school was soon to be formally known by the name it has used since: the School of the Art Institute of Chicago.

The impetus for this book began as a way to better understand these early years of the institution, from its growth and movement from rented rooms to elegantly appointed studios and galleries to its purpose-built civic landmark. In 1894, the new building was completed east of Michigan Avenue, almost centered in the city and facing the edifices of the unstoppable metropolis. The school and museum truly took its place as an institution of unparalleled significance in the city's cultural birth.

Our initial forays into the archive were undertaken with a sense of curiosity and with the pure pleasure of discovering new information. The curiosity grew into a project, and the project has become this book. By no means an attempt to be definitive, this work is an initial entry for us into a much larger story. This book is an overview of the history of the school, from the point of view of its locations, its buildings, and its significant moments. In the process of selecting the images herein, we quickly began to realize that no other book has told our story in quite this way. Concentrating upon the pictorial provided new insights

and information, bringing clarity to the narrative previously developed by former dean Roger Gilmore in his 1982 book *Over a Century*.

We have divided the book into eight chapters, with the first seven covering the 15 decades since 1866, broken out through phases of development tied to the key moments of the school.

The first decades lead up to the appointment of William French, a civil engineer, artist, lecturer, and historian renowned by that time as skilled and perceptive. French built on the foundational work that Volk had begun. It could be argued that this period in the life of the School of the Art Institute of Chicago was its renaissance and the World's Columbian Exposition of 1893 coincided with its coming of age.

The periods up to and following World War I and then the Great Depression clearly carry very different characteristics. The institutional transitions at stake in the interwar years took SAIC from being a beaux-arts academy in the French tradition to an American contemporary arts institution of international significance. Following World War II, the focus of SAIC shifted toward developing technical resources and creating departments to support the academic growth of experimental work in the arts. Significant also is the focus upon student life and well-being. Establishing a balance between personal needs and social conditions preoccupied the students in the postwar years, and as personal politics took on a national dimension, SAIC engaged fully, giving rise to a confirmed recognition of art and design as a social practice.

The 1970s saw the coming together of arts and technology and a renewed interest in the relationships between the arts and sciences. Students and faculty introduced electronic media of all kinds to their studios. The most recent decades have been typified by the growth of public and civic practices and the supporting of ideas that position the artist and scholar as an activist, curator, historian, educator, therapist, critical practitioner, and public intellectual as well. Social engagement demands close contact with the city, and the seventh chapter concludes in the present moment following the public celebrations of the school's 150th year.

The final chapter looks at the school through the lens of its core values. In researching the dates, events, and experiences of the school, we saw the core values reflected back. Frequently, for many who have been involved in the school, there is a love expressed for the unique creative, social, and intellectual environment of SAIC. The institution has been shaped by a shared commitment and enthusiasm renewed every year by the vigor and energy of its students. Recognizing that the images in this book offer only the briefest glimpses of the experience of being at the school, we hope the book will serve to facilitate additional points of reflection upon which to cultivate the foundation of the next 150 years.

One

1866–1893

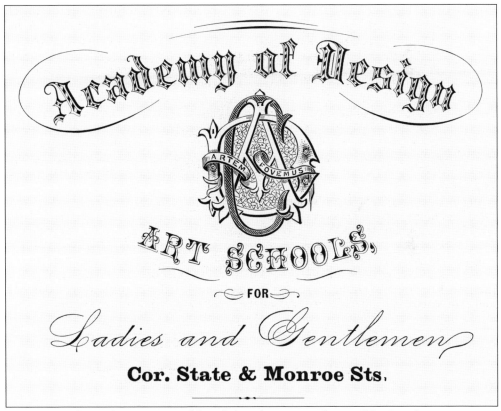

This logo is from the 1878 pamphlet of the Chicago Academy of Design that announces, "Instruction in Drawing from the Cast, and from Life. Modelling in Clay; Landscape Painting, in Oil and Water Colors, with weekly Lectures on kindred Art subjects, embracing, also, Architecture, Perspective, and Illustrative Geometry."

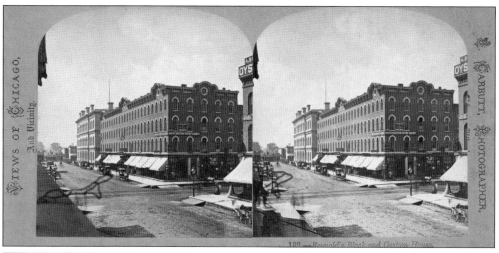

Amusements.

CROSBY'S OPERA HOUSE.

Chicago Academy of Design

ENTERTAINMENT.

Crosby's Opera House,

Friday Evening, May 3, 1867.

DIRECTOR OF THE EVENING'S ENTERTAIN-
MENT, MR. FRANK E. AIKEN.

The Chicago Academy of Design will give a Literary,
Musical and Dramatic Festival at Crosby's Opera
House, on Friday evening, May 3d, 1867. The Ger-
mania Maennerchor, Frank E. Aiken, Esq., Prof. Hans
Balatka, the Turner Gemeinde, Chicago Musical
Union, Mr. Henri De Clerque, Mr. Lisle Harkness, Mr.
Cramer, Captain De Pelgrom, and a number of other
gentlemen, have kindly volunteered to assist on the
occasion.
Mr. U. H. Crosby has generously volunteered the use
of the Opera House.

PROGRAMME.
MUSICAL DIRECTOR, HANS BALATKA.
1. Grand Overture from William Tell (Rosini).
2. Oration—Hon. George C. Bates.
3. Chorus from Tannhauser (Richard Wagner)—Ger-
mania Maennerchor.
4. Recitation—Amateur.
5. Tableau Vivant—Conflict of Thermopylæ; ar-
ranged by Louis Kurz—Turner Gemeinde.

INTERMISSION.

The origin of the School of the Art Institute of Chicago can be traced back to 1866. In that year, 35 local artists met in a building on Dearborn and Madison Streets known as Reynold's Block. This stereograph of the Reynold's Block and Custom House was made about 1865. The Chicago Academy of Design members intended to institute a free school of life and antique drawing and to run a gallery that would sponsor literary, musical, and dramatic events. (JPGM, Los Angeles, Gift of Weston J. and Mary M. Naef. John Carbutt, Reynold's Block and Custom House, about 1895, albumen silver print.)

This public announcement appears in the May 2, 1867, *Chicago Tribune*. Led by Charles Peck, Walter Shirlaw, and Sheldon J. Woodman, the members held a successful exhibition at Crosby's Opera House on May 3. (CT.)

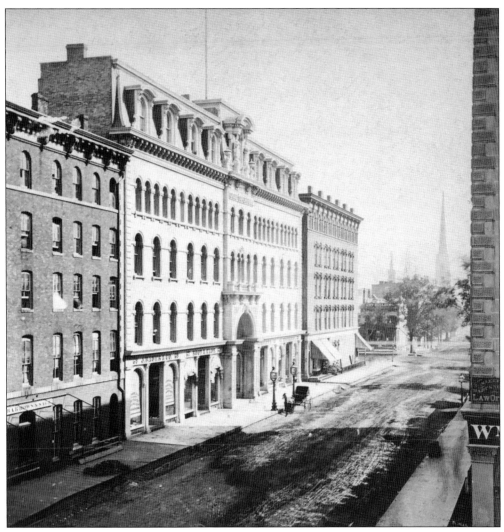

From 1867 to 1870, the Chicago Academy of Design held functions in Room 28 of Crosby's Opera House (pictured). A new curriculum modeled after successful contemporary European academies helped create a situation where the number of course offerings and class sizes increased rapidly. An account given by Alfred Theodore Andreas in his *History of Chicago: From 1857 until the fire of 1871* relays the following details: "On November 18, 1867, a meeting of the principal artists in the city was held at Crosby's Opera House for the purpose of reorganizing the Academy upon a sure basis, founded upon principles broad and liberal, and incorporating features tending to elevate the character and condition of the arts of design. A revised constitution was adopted. Leonard W. Volk was solicited to act as president, a position which he filled until 1878, with marked ability and harmonizing influence. 'Life,' 'Antique' and 'Rudimentary' drawing-schools were opened in Room 28, [of the] Opera House in January 1868. No Salaries were paid, all labor, including tuition, being rendered gratuitously." (NYPL Digital Collections. Accessed June 8, 2016. http://digitalcollections.nypl. org/items/510d47e0-5b70-a3d9-e040-e00a18064a99.)

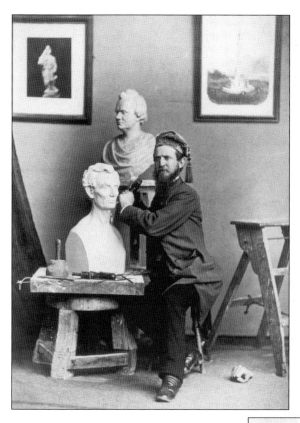

Leonard Wells Volk (1828–1895) was an American sculptor who is notable for making one of only two life masks of Abraham Lincoln. In 1867, Volk and a group of fellow artists established the Chicago Academy of Design, and Volk served as its president from 1870 to 1878. Volk made several large monumental sculptures, including the tomb of the politician Stephen A. Douglas, located at Thirty-Fifth Street and the lakefront in Chicago. (CHM, ICHi-12759; Hamilton Ostendolf, photographer.)

The casts of Lincoln's hands and face made by Volk are considered to be a priceless legacy of Lincoln's likeness. They have served as the models for every sculpture made of the president since Volk gave an animated account of the series of sittings Lincoln gave him, remarking on the "great man's" hands in particular. In his article "The Lincoln Life-mask and How It Was Made," in the December 1881 *Century* magazine, Volk recalls that upon arriving at Lincoln's home in Springfield, Illinois, on May 18, 1860, he exclaimed, "I am the first man from Chicago, I believe, who has the honor of congratulating you on your nomination for President. Then those two great hands took both of mine with a grasp never to be forgotten." (CHM, ICHi-52644.)

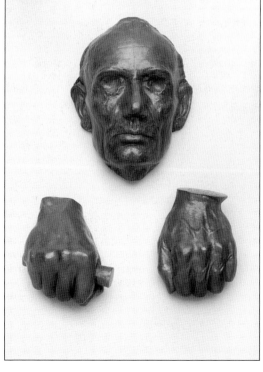

At the invitation of the Mayor William Butler Ogden, known as the father of the city of Chicago, George Peter Alexander Healy (1813–1894) came to Chicago in 1855. Healy was a founding member of the Chicago Academy of Design and was one of the most prolific and popular painters of his day. He maintained a studio in Crosby's Opera House. (CHM, ICHi-68128; John Carbutt, photographer.)

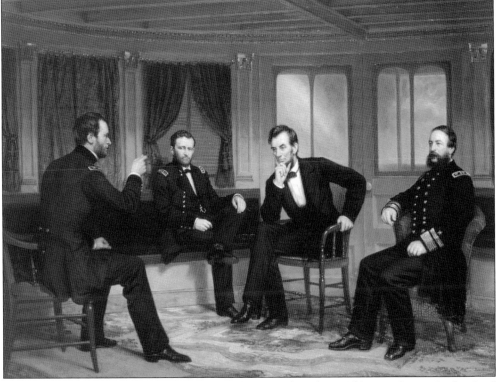

George P.A. Healy's painting *The Peacemakers*, produced in 1868, now hangs in the Oval Office Dining Room. It depicts the historic strategy session (March 28, 1865) by the Union high command on the steamer *River Queen* during the final days of the Civil War. Maj. Gen. William Tecumseh Sherman is depicted speaking on the left to General-in-Chief Ulysses S. Grant, President Lincoln, and Rear Adm. David Dixon Porter. General Sherman writes in a November 28, 1872, letter to Isaac Newton Arnold: "It is certain that we four sat pretty much as represented, and were engaged in an important conversation during the forenoon of March 28, 1865, and that we parted never to meet again." (WHHA, White House Collection.)

The New Building of the Academy of Design, Chicago.

(For Description see page 244.)

This drawing depicts the Academy of Design building, which stood from 1870 to 1871. "The academy building had been constructed especially to meet the wants of the artists. It comprised eighteen studios, all of which had been engaged before the building was finished. It was, indeed, a beautiful home for the arts, and for those who were making art a profession. The gallery was spacious. For fine proportion for a new elevation and clear light, it was not surpassed in this country. The lecture-room was ample, and the handsomest in the city; the reception-room and studios, the staircases, approaches, school-rooms, were all fitted up in a style of elegance that speedily won the popular favor," according to Alvah Bradish in his letter published as "A History of its Destruction" in the November 16, 1871, *Chicago Tribune*. (CHM, ICHi-85798.)

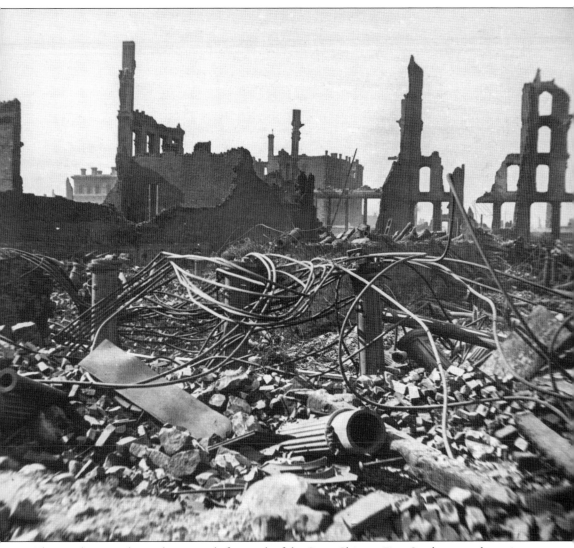

This stock image shows the general aftermath of the Great Chicago Fire. On the second evening of the Great Fire, October 9, 1871, at 10:00, Alvah Bradish witnessed the final destruction of the academy, which he recounts in his letter published in the November 16 *Chicago Tribune*: "Was there any hope now left for the academy? Soon, through its broken windows, down through its noble expanse of skylight, came the whirlwind of flames and murky elements, down crushed timbers and walls, staircases, pictures, casts, —all the precious works that filled the studios of absent artists,— now all on fire, and adding intensity and grandeur to the whirling volcano of the interior, —a blackened, burned mass of art ruins for one moment then shot up a sharp dazzling spire of red flame, far into the impending smoke-cloud that rolled like a pall over the expiring structure, as though to proclaim a savage triumph over the fond hopes and labors of genius. Thus perished the Chicago Academy of Design." (NL.)

The Schureman and Hand Marble Mantel Company Building was located on the southwest corner of Michigan Avenue and Van Buren Street. Three years after the Great Fire, classes resumed in rented rooms and ran successfully from 1874 to 1877. This building also housed artists' studios, including that of the academy's president, Leonard Wells Volk.

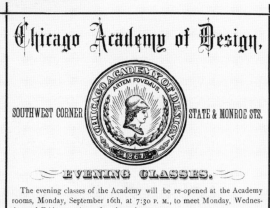

Chicago Academy of Design,

SOUTHWEST CORNER STATE & MONROE STS.

EVENING CLASSES.

The evening classes of the Academy will be re-opened at the Academy rooms, Monday, September 16th, at 7:30 P. M., to meet Monday, Wednesday and Friday evenings of each week.

THE LIFE CLASS will be under the direction of Mr. L. C. EARLE. This class is intended for advanced students, drawing and painting from life, and all pupils, except old members, will be required to submit satisfactory drawings from the cast or from life.

TERMS : Four Dollars a Month, or Ten Dollars for Three Months, in advance.

DRAWING FROM THE ANTIQUE.—A class in drawing from the cast will meet at the same time—7:30 P. M., Mondays, Wednesdays and Fridays—also under Mr. Earle's direction. Another teacher will be provided if necessary. All the casts and copies of the Academy will be at the service of this class, and an opportunity will be given to persons desiring to enter the Life Class to make their preliminary studies.

TERMS : Three Dollars a Month, or Eight Dollars for Three Months, in advance.

The Academy offers improved facilities in many respects, and students can rely upon the best opportunities and the most competent instruction. An evening costume class is proposed. The regular day-school is in session as usual, Mr. Spread and Mr. Earle, teachers. Terms, $10 a month ; $6 a month for half-time.

For full particulars apply to

CHICAGO ACADEMY OF DESIGN, }
September 1st, 1878. }

W. M. R. FRENCH, Sec'y.

Pictured here is an advertisement for evening classes at the Chicago Academy of Design on September 1, 1878. (CHM, ICHi-92693.)

New Hampshire native and Harvard-educated engineer William Merchant Richardson French (1843–1914) first came to Chicago in 1867 to pursue a career in civil engineering and landscaping. While working in Chicago, French garnered a national reputation for his lectures and articles on art subjects. In 1878, French became secretary of the Chicago Academy of Design, which was later reorganized as the Chicago Academy of Fine Arts in 1879. The academy changed its name to the Art Institute of Chicago in 1882, and French became the secretary of this new corporation and its first director in 1885, holding this position until his death in 1914.

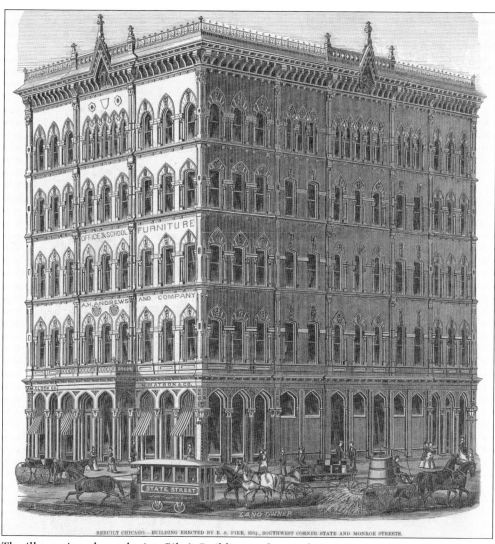

REBUILT CHICAGO.—BUILDING ERECTED BY E. S. PIKE, ESQ., SOUTHWEST CORNER STATE AND MONROE STREETS.

The illustration above depicts Pike's Building at the southwest corner of State and Monroe Streets. Below is the letterhead used at this location from 1879 to 1882. In 1877, the academy relocated to Pike's Building, where it stayed until 1882. At this location in 1879, the Chicago Academy of Design was reorganized to form the Chicago Academy of Fine Arts. The aims of the reorganization were the "maintenance of schools of art and design, the formation, and exhibition of collections of objects of art, and the cultivation and extension of the arts of design by any appropriate means." The transition from one organization to the other was seamless. On June 29, 1879, under the heading "Art Notes. The New Academy," the *Chicago Tribune* reported: "The movement in behalf of a new institution which resulted some weeks ago in the organization and incorporation of the Chicago Academy of Fine Arts is going steadily forward. . . . It has not been closed for a single day. The new institution bought the school furniture and appliances, and carried the school through the uncompleted term, which ended yesterday." (Above, CHM, ICHi-85797.)

The Chicago Academy of Fine Arts.
S. W. Cor. State and Monroe Sts.
(ELEVATOR ON MONROE STREET.)

THE·ART·INSTITVTE
·OF·CHICAGO·

·ART· ·THEORY· ·PRACTICE· ·HISTORY·

Seen above is an early logo of the Art Institute of Chicago. Pictured at right in 1882, Charles Hutchinson was elected as president, and the name of the Academy of Fine Arts was changed to the Art Institute of Chicago. A man of great reputation and a business background, Hutchinson was born in Lynn, Massachusetts, in 1854. His family moved to Chicago in 1856, and in 1863, he became one of the first directors of the First National Bank of Chicago. Together, Hutchinson and French directed building projects, including the existing 1894 structure with its iconic lions. They also developed relationships with art dealers in Europe, which allowed for a series of foundational acquisitions of art and study materials for the school.

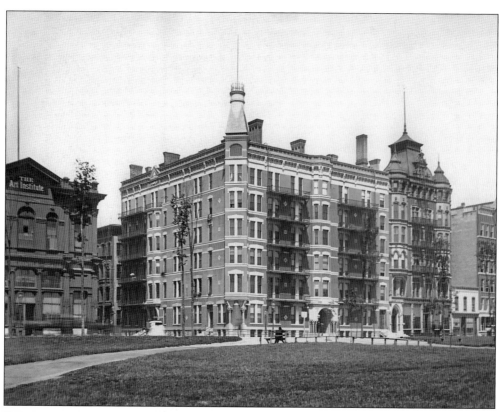

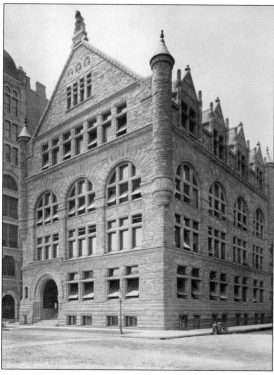

In 1882, the Art Institute purchased the land under the Schureman and Hand Marble Mantel Company and leased the building the academy had occupied from 1874 to 1877. The building is shown to the left in the above image. The Art Institute of Chicago then erected a new building behind it to contain its exhibition galleries and schoolrooms.

Three years later, the trustees determined that these makeshift accommodations ought to be replaced by a permanent fireproof building. After the old buildings were torn down in 1885, a new building designed by Burnham and Root was completed in 1887. Located on the corner of Michigan Avenue and Van Buren Street, the school occupied 12 rooms in this building until 1893, when it moved to its present location on Michigan Avenue. The building was purchased from the Art Institute by the Chicago Club in 1893.

This interior view shows the Art Institute of Chicago in 1887. Designed by the iconic firm of Burnham and Root, the proportions and decoration reflected the finest Beaux-Arts styling of the day.

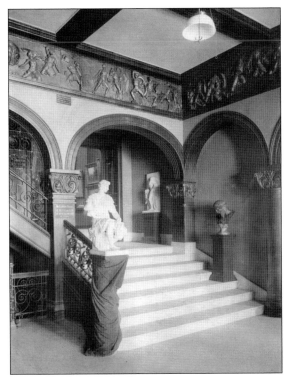

Depicted here is one of the picture galleries. Charles Hutchinson oversaw some of the most significant early purchases. Clearly visible in the corner of this display is a replica of Dante Gabriel Rossetti's *Beata Beatrix*. Painted by the artist, it is a key feature of the Art Institute's collections. A predella in the small panel at the bottom, showing Dante and Beatrice's last meeting in paradise, distinguishes this copy from the original, which is at the Tate Gallery in London.

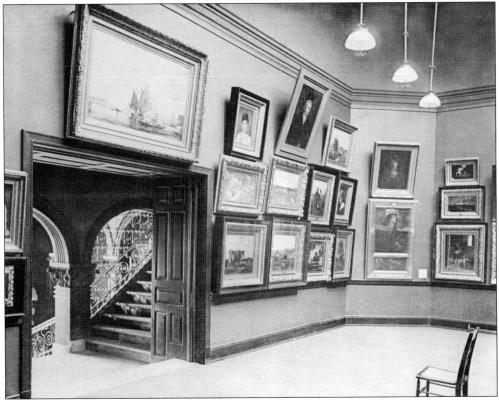

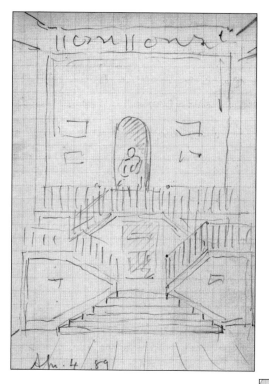

Pictured here is an excerpt from the 1889 travel notebook of William M.R. French. In May 1889, French and Hutchinson set out on a two-month fact-finding trip to Europe. Alongside meeting students and alumni from Chicago, they also visited museums, private collections, artists, and dealers. French took careful note of significant artworks, architectural details, and exhibition display methods, many of which contributed to the formation of the Art Institute as it is known today.

This entry from May 14, 1889, details the syllabus for the Paris Beaux-Arts examination. The main elements French describes are "1. Nude charcoal full-length from life on charcoal paper. 12 hours.; 2. Anatomy, scapula and connection, outside view, full size, in any medium. 8 hours. This confined to bones and must be executed from memory; 3. Perspective. This time a large vase and pedestal as on canvas for painting showing vanishing points.; 4. Architectural design. To draw a triumphal column in Roman Doric architecture, trophy to be half way up the column.; 5. Written history exam. A question taken from a list of 35 questions from which the students are prepared. In this case, describe 3 scenes for designs for tapestries illustrating an incident in the lives of Chas. 5th and Du Gaselin making accessions xc.; 6. Modeling. Head from cast (antique) full size, one day."

Two

1894–1914

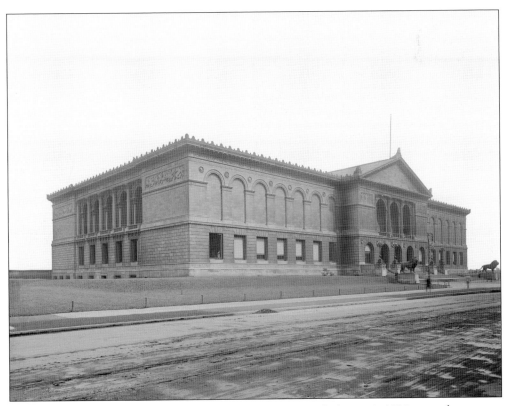

Director William M.R. French writes in the Art Institute of Chicago's 1893 annual report to trustees and members: "There is reason to apprehend that the new building, large as it is, will hardly be large enough for our uses when we come into full possession of it—Respectfully W.M.R. French Director." (CHM, ICHi-85800; Barnes-Crosby, photographer.)

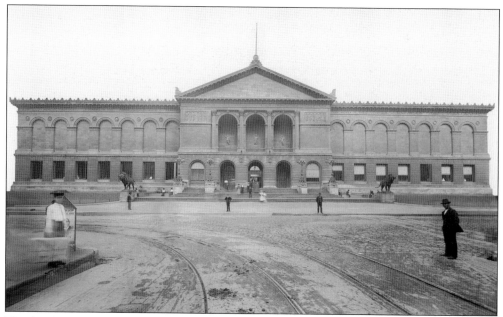

The Art Institute soon outgrew the capacity of the 1885 Burnham and Root building. In 1883, a total of 359 students were attending classes, and by 1893, this number had almost tripled, reaching 929. A new building planned in cooperation with the World's Columbian Exposition of 1893 was constructed with the purpose of expanding the school and museum following the exposition. (CHM, ICHi-19219; Barnes-Crosby, photographer.)

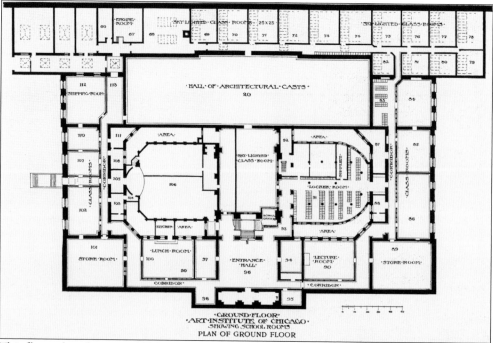

This floor plan shows an 1895 expansion of school accommodations to include a north and south wing along its eastern side.

In 1889, day and evening classes in architecture were begun under the direction of Louis Millet and William Otis. Instruction was provided in mathematics and construction as well as in drawing and design.

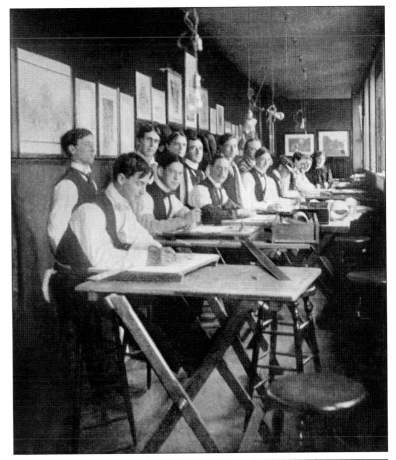

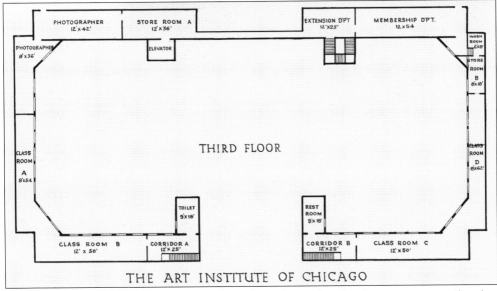

PHOTOGRAPHER
12' x 42'

STORE ROOM A
12' x 36'

EXTENSION D'P'T
12' x 25'

MEMBERSHIP D'P'T.
12 x 54

PHOTOGRAPHER
8' x 36'

ELEVATOR

WASH ROOM
6 x 8'

STORE ROOM
B
8 x 18'

CLASS ROOM A
8' x 54'

THIRD FLOOR

CLASS ROOM
D
8 x 62'

TOILET
9' x 18'

REST ROOM
9' x 18'

CLASS ROOM B
12' x 50'

CORRIDOR A
12' x 25'

CORRIDOR B
12' x 25'

CLASS ROOM C
12' x 50'

THE ART INSTITUTE OF CHICAGO

This plan of the third floor from 1911 shows how the roof and attic spaces were utilized as classrooms and studios.

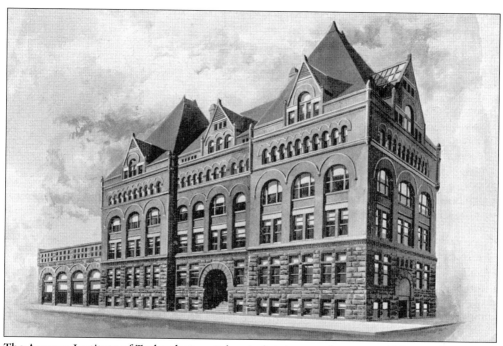

The Armour Institute of Technology was located at Armour Avenue and Thirty-Third Street in Chicago. An alliance between the school and the Armour Institute resulted in the Chicago School of Architecture. The former furnished instruction in artistic and technical studies, and the latter offered instruction in scientific and mathematical branches.

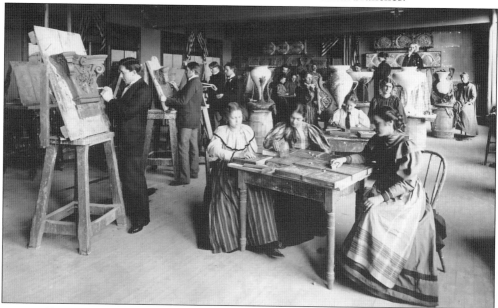

Pictured here is an ornament class at SAIC. Great emphasis was placed upon the practical application of artistic concepts in decorative design. Although design was introduced into the curriculum in about 1885, the department was not fully developed until the 1890s. The study of theory and manual practice alternated with problems in original design for stained glass, rugs, book covers, capitals or columns, and other utilitarian objects.

Here is a portrait of John Vanderpoel (1857–1911). Vanderpoel's career began as a student at the Chicago Academy of Design, and after studying at the Académie Julian in Paris, he returned to Chicago, where he became an instructor. Here, he developed a pedagogical method for representing the human figure based on careful observation of light and understructure: "The shape of every shadow is accounted for by the projection above it and the surface on which it lies." Vanderpoel loved to tell an anecdote about his studies in Paris: his teacher had ridiculed him for putting six toes on the model's foot in his drawing, but it turned out that the model actually did have six toes—Vanderpoel had been the only one to notice this.

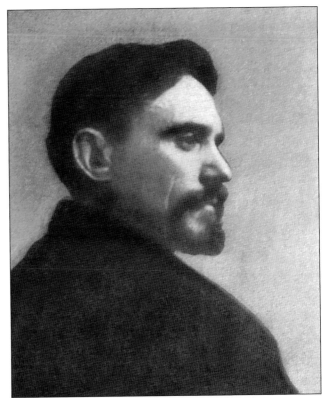

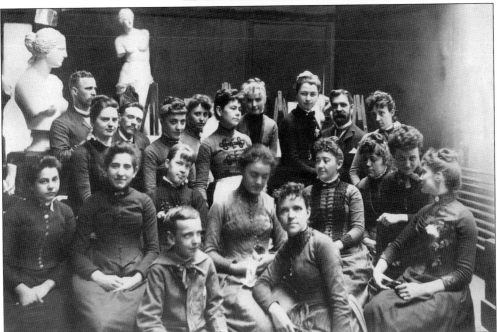

Notable faculty member John Vanderpoel can be seen here in the back row, third from left, and director William M.R. French is standing in the back row, second from right. (UIA, Lorado Taft Papers, 1857–1953, 0006292.)

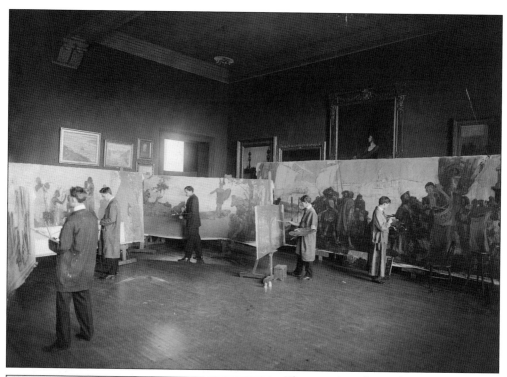

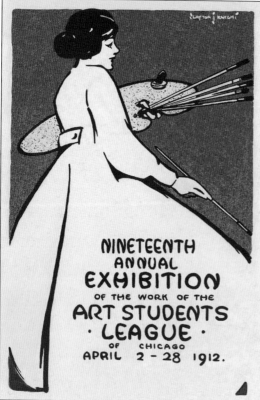

The practice of mural painting offered an opportunity to synthesize the "applied" and "fine" arts. Students were provided with the chance to design and execute murals in high schools and park houses in Chicago. In this photograph, African American painter William Edouard Scott (1884–1964), third from the left, is working on *Landing of the Norsemen*, a prize commission for Chicago's Felsenthal School. Scott studied under John Vanderpoel from 1904 to 1907; he is best known for his mural *Commerce* at Chicago's Lane Tech High School.

Seen here is a catalog for the Annual Art Students' League exhibition. Formed by students from the School of the Art Institute of Chicago, the Art Students' League of Chicago exhibited annually at the Art Institute from 1893 to 1944.

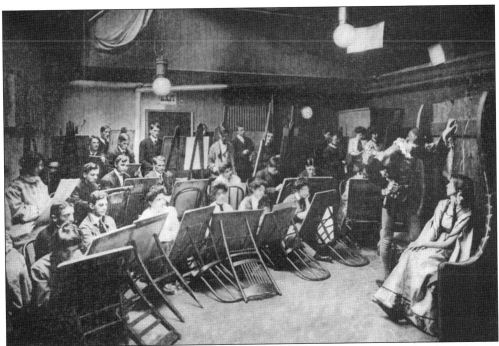

Above is a figure drawing class, and below is a painting class from the "Flat." In the 19th century, art education classes were characterized by their focus on artifacts and subjects. The terms "Life," "Flat," and "Antiquities" refer respectively to drawing from live models, drawing from two dimensional originals and reproductions, and drawing from three dimensional artifacts including models, casts, and original objects. Anyone could enroll in the drawing classes from the Flat since there were no entrance requirements.

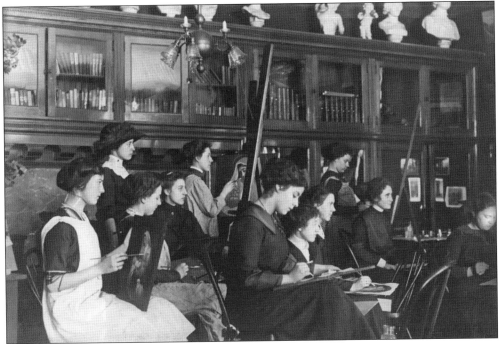

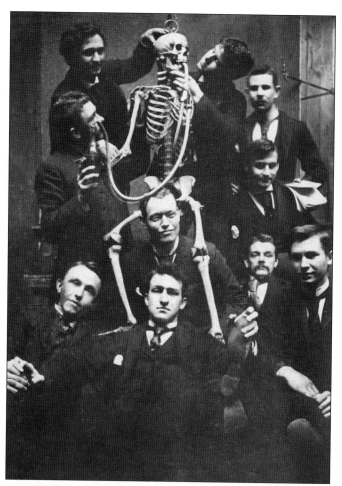

Faculty member John Vanderpoel is pictured second from right. A course in artistic anatomy was offered to help students understand the structure of the human body. It consisted of two series of lectures: one dealing with bones and the other with muscles. Both were illustrated by drawings, nude models, skeletons, casts from dissections, and photographs.

An antiquities or antique drawing class poses below. In order to progress to the antique class, a student had to submit three drawings from the Flat to the committee; in order to draw or paint from life, three drawings from the antique course were submitted. Thus, advancement was entirely dependent upon the acquisition of skills rather than a prescribed pathway.

Evening class instructor Antonin Sterba is shown in both pictures with his students. Evening classes had loyal followers who appeared to register for classes term after term, year after year. There was a record of attendance, but no grades were kept. Students come to evening school from a variety of backgrounds. The Czech-born artist Sterba received honors as a student and established himself in the Midwest as an accomplished landscape and still-life painter and printmaker. He taught evening class at SAIC from 1910.

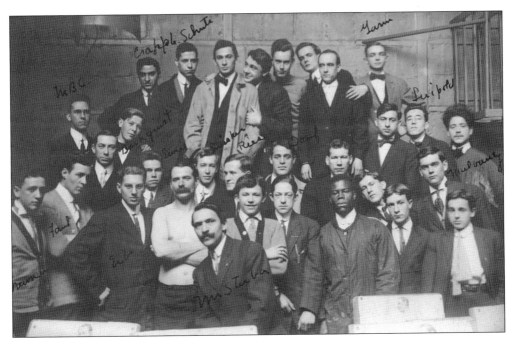

Lorado Taft (1860–1936) was famous for the creation of monumental sculpture. Having studied at the École des Beaux-Arts in Paris from 1880 to 1883, he taught at the Art Institute from 1886 to 1929. (UIA, Alumni and Faculty Biographical File, 1882–1995, 0003829.)

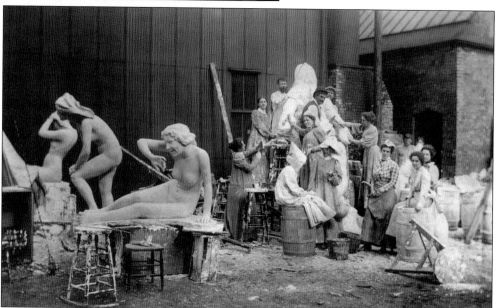

Taft's students are shown here working on *The Nymphs*. The students had to confront the same problems that professional sculptors did, even though the pieces they produced were made of plaster and intended to endure for a limited time only. Besides learning how to model busts in clay, students had to acquire skills of setting up their own armature for large figures, casting them in plaster, and even cutting them in marble. (UIA, Lorado Taft Papers, 1857–1953, 0006270.)

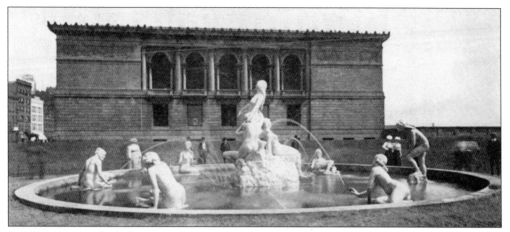

In 1899, just south of the Art Institute in Lake Front Park, renamed Grant Park in 1901, Taft's class set up a fountain in the form of a group of nude female figures known as *The Nymphs*. This fountain caused a great deal of public consternation, not only because of the nudity of the subjects but also because it had been executed by women.

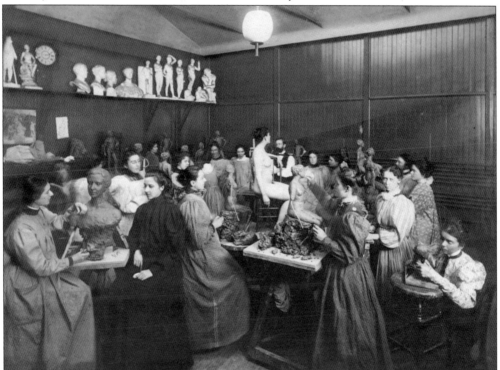

Lorado Taft is seen here teaching a figure modeling class. Taft, who founded the sculpture department, had a strong belief in the importance of the use of live models as the source of the composition. A *Chicago Post* article written in 1905 quotes him as saying, "I have always found it difficult to teach students to work away from a model. . . . When they are faithfully following the lines of a posed model the ideal conception vanishes and they see only the commonplace before them, and when the imaginative picture is in their minds and they have no model, they lack the courage to create it from the clay." (UIA, Lorado Taft Papers, 1857–1953, 0002716.)

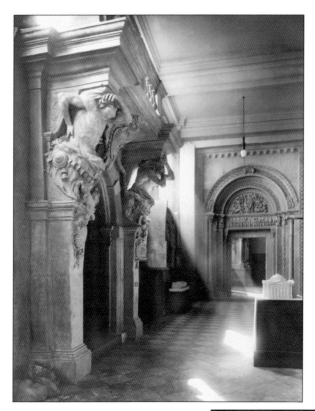

Blackstone Hall, the former sculpture court on the east side of the main building, was a focal point of the Art Institute's collection in the early decades with casts of cathedral facades, equestrian figures, and architectural elements.

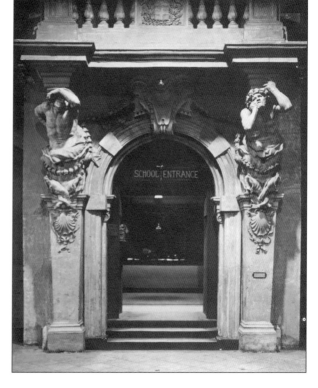

At the north end of the hall, this stone entrance framed the main office of the school and studios. The doorway was copied after the portal of the city hall of Toulon, France, by the French artist Pierre Puget (1620–1694). On each side of the door is a caryatid, respectively "Force" and "Fatigue." The door was destroyed when a new boiler room was built in that location.

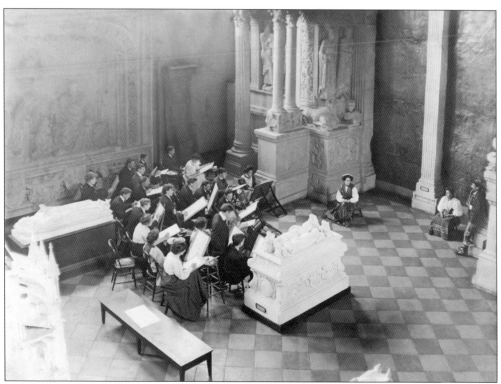

Classes were held throughout the galleries of the museum, and models were frequently posed amongst the architectural elements in Blackstone Hall. Classes also took advantage of the southern light in the exterior galleries on the second floor of the museum.

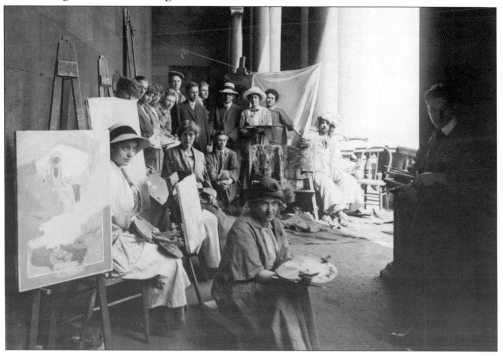

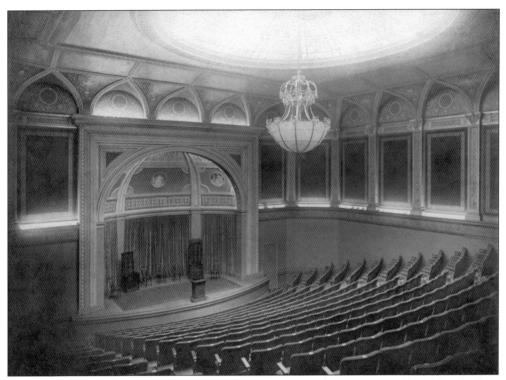

Seen here is Fullerton Hall where, in 1894, courses in art history were offered for the first time under George Schreiber. A list of the lectures given in 1889 includes the following topics: "Rembrandt, the Shakespeare of Art," "Dignity versus the Picturesque," "An Art Student's Life in Paris," and "Art and the Intellectual." Two renowned artists who visited the school during this period made a particularly strong impression on students: Alphonse Mucha, in 1906, and Joaquin Sorolla y Bastida, in 1910.

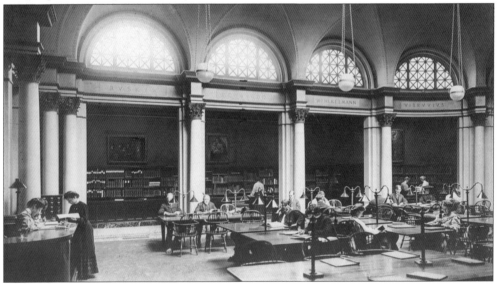

The Ryerson Library was founded in 1879 for the use of students of the school and museum members. School fees were collected for the purpose of expanding its holdings.

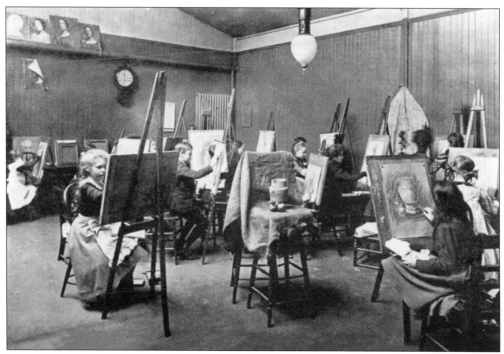

Children's art classes included techniques training that paralleled the adult classes. Above, the children learn still life, and below, figure drawing. The school held children's classes on Saturday during the regular term as part of the Normal Department training. These classes were first mentioned in an 1887 program sheet announcing "classes intended for children and teachers, Saturdays, 10:00–12:00 a.m."

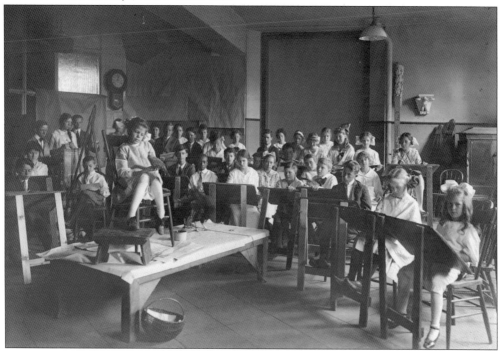

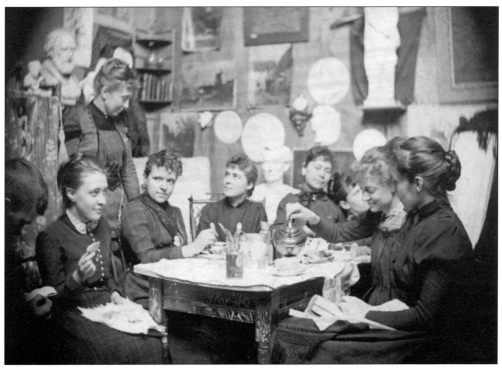

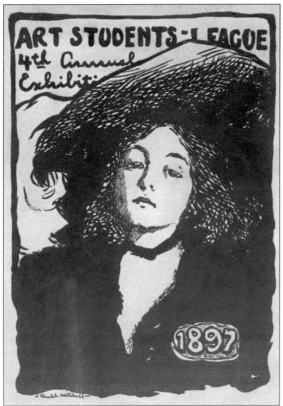

Most students were female, and some visitors to the school were startled by the sight of women wielding hammers or hatchets. A reporter for the students' magazine, *Brush and Pencil*, asserted, "Nor does their work suggest in the least any of those evidences of timidity or effeminacy which the world in the past predicted would ever prove a stumbling-block in the way of woman's success in sculptural art; on the contrary, these girls plunge into their work with an energy and a determined fierceness which proves them to be possessed of all the courage of a Phidias, even if some of his other attributes be lacking."

Pictured here is the catalog cover for the Fourth Art Students' League Exhibition. Formed by students from the School of the Art Institute of Chicago, the Art Students' League of Chicago exhibited annually at the Art Institute from 1893 to 1944.

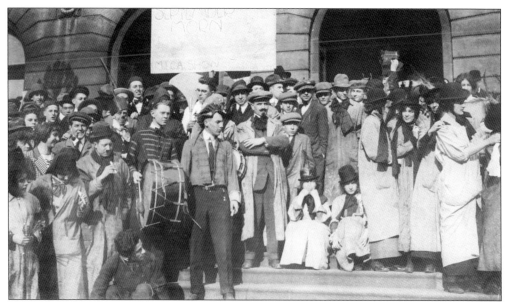

Students protest on the steps of the Art Institute in March 1913. A mock trial was staged that questioned the morality of the painting *September Morn*, a female nude by French artist Paul Chabas. Though it was previously shown in Paris without issue, its exhibition at the 1913 Armory Show in Chicago was to be the focus of an outcry. Students demonstrated in order to draw public attention to the potential indecency. On April 17, the last day of the Armory Show, students staged a mock trial, but this time of the work of Henri Matisse, who was lampooned as Henry Hairmatress. Reproductions of three of Matisse's paintings were brought forth as evidence, tried, and then burned as "monsterpieces."

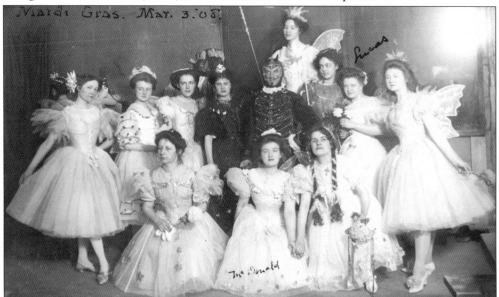

There were lots of elaborate parties and pageants, including an annual Mardi Gras costume ball that was organized around a different theme every year. One year, the motif was "the Arabian Nights," and the props included a live camel, which was allowed to roam about freely in the museum's Blackstone Hall.

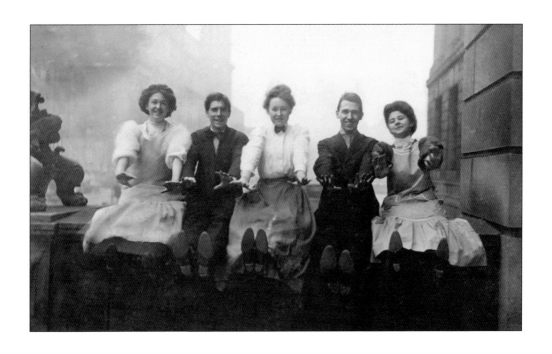

In 1897, the school had taken a survey of students to discover their future plans. The results indicated a nearly equal numerical division between those who were interested in devoting themselves to fine art and those who intended to apply their artistic skills in some practical field. Of the 530 students polled, 117 hoped to become artists, 129 illustrators, 17 sculptors, 17 architects, 52 decorative designers, and 68 teachers; 38 desired to improve themselves in a present occupation; and 41 had no definite plans.

Three

1915–1945

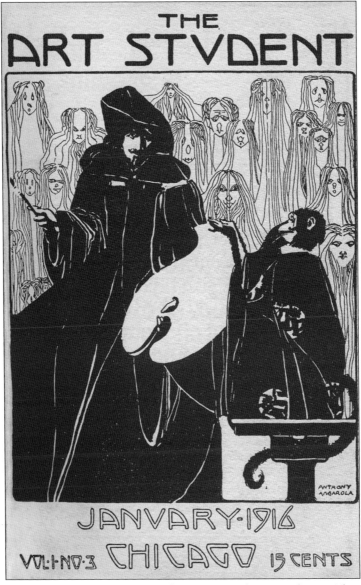

In his 1982 book *Over a Century*, Roger Gilmore writes that according to Theodore Keene, dean of the school from 1914 to 1918, "There is no question about it, art offers a better living to the trained youth today than ever before. We are on the start of a newer and wider movement in commercial art. I mean that wide field which covers illustration and the new form of advertising." This image shows a cover of the student periodical the *Art Student*.

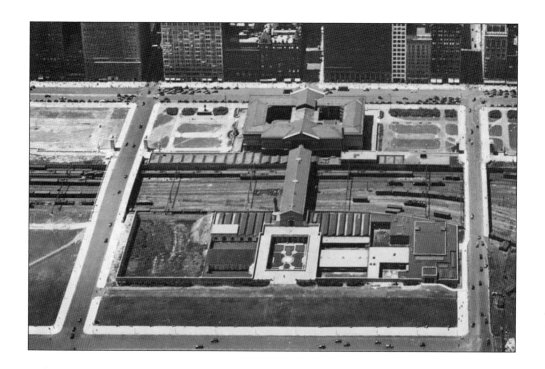

Above, an aerial photograph shows the new school buildings constructed in 1927 to connect McKinlock Court with the foyer of the Goodman Theatre. The lower school occupied most of these new classrooms, permitting all the school studios west of the Illinois Central Railroad tracks to be used for the upper and middle schools. Of the buildings along Michigan Avenue not occupied by the school at that time, the Illinois Athletic Club building at 112 South Michigan Avenue can be seen before the addition of its extra floors. The floor plan below shows additions principally in the space labeled "Court F" that were completed in 1931, providing three new studios, some offices, a small exhibition room, and a meeting room for the faculty.

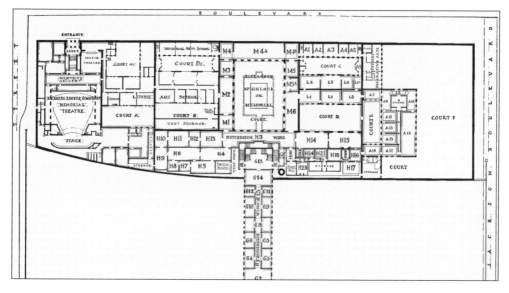

A painting class is seen here in McKinlock Court. In his memoir, Norman Rice (dean from 1938 to 1943) recalls his time as a student: "We worked not only in our assigned classrooms but all over the Museum—drafting the casts, the stairways, the decorative arts galleries, and spilling over into the vast, richly endowed collections of the Field Museum. And of course, there was the busy lakefront and all of Chicago. The School, then as later, was long on students and short on space."

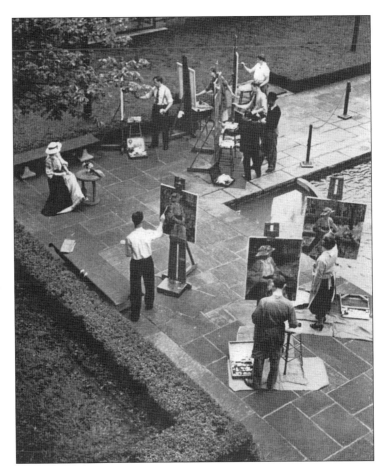

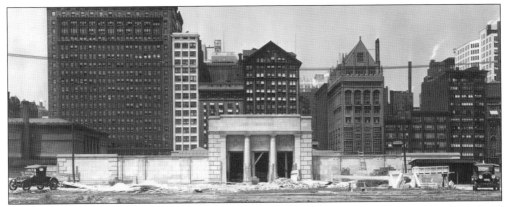

The Goodman Theatre and the Goodman School of Drama were established at the School of the Art Institute in 1925 on the bequest of the parents of Kenneth Sawyer Goodman. The original building was designed by leading American craftsman architect Howard Van Doren Shaw. In 1978, the Goodman School of Drama moved to DePaul University. Then in 2000, the Goodman Theatre Company took up its place in the city as an independent institution, in a new building at 170 North Dearborn Street.

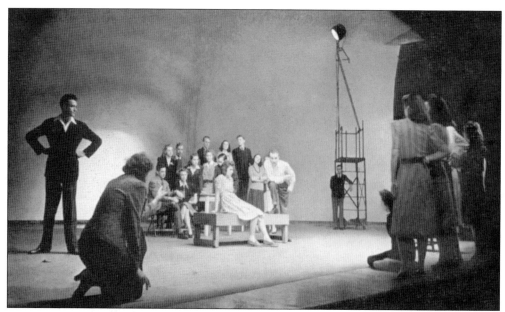

This undated photograph shows a drama class in the Goodman Theatre.

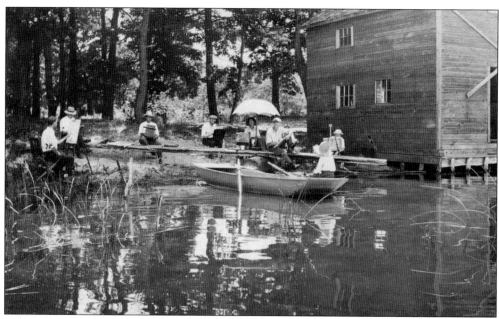

The Ox-Bow Summer School of Painting is pictured in Saugatuck, Michigan. In 1908, Frederick Fursman and Walter Marshall Clute, graduates of the school, began teaching summer painting class at Bandle Farm on the east bank of the Kalamazoo River, approximately one mile upstream from Ox-Bow's present location. Its success and growth benefited from a developing tourist industry, and by 1915, with significant private support, the alumni association entered into a partnership with Fursman, which allowed for the purchase of the land and buildings in its current location. Ox-Bow's mission is to provide a haven for artists, and the relationship between Ox-Bow and SAIC, forged by Fursman and Clute, remains strong today.

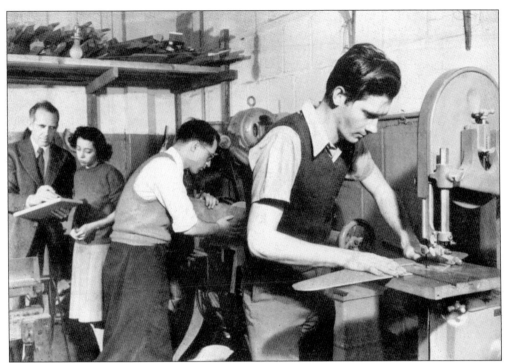

The establishment of technical shops following the Great War typified a more pragmatic approach toward art education at SAIC. A growing emphasis on industrial art between 1918 and 1933 was spurred on by the close of World War I and the onset of the Great Depression. The Department of Industrial Arts, headed by architectural sculptor Emil Zettler, was formally established as a separate branch of the school in 1929.

In this photograph, a class studies design for print. An emphasis on product design led to classes in plain lettering, pictorial poster making, and the printing of yard goods, cretonnes, velours, tablecloths, napkins, scarves, draperies, wall hangings, wallpaper panels, toys, and furniture.

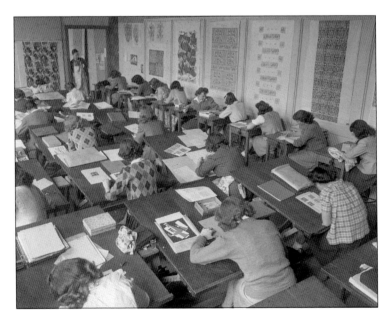

This photograph of Helen Gardner (1878–1946) is from the 1925 *The Bronze Lion*, which remains the only yearbook ever to be produced at SAIC. Gardner was appointed head of the Photograph and Lantern Slide Department of the Ryerson Library in 1919, and in the autumn of 1920, she began delivering a lecture course in art history at the school. She taught until she died in 1946. "Of many remarkable things Miss Gardner did, her greatest achievement by far was writing *Art Through the Ages*, a pioneering attempt to provide—in defiance of narrow tradition—a one-volume survey of the history of art. The book clearly filled a crying need; its success was immediate," writes Harold Allen in the essay "Helen Gardner: Quiet Rebel," in Lisa Stone and Jim Zanzi's book *Sacred Spaces and Other Places*, published in 1993 by the School of the Art Institute of Chicago.

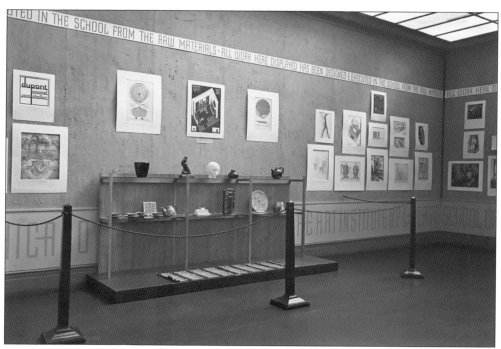

The *42nd Annual Exhibition of the School of the Art Institute of Chicago* shows student work in the museum in 1935. The banner text around the upper wall reads, "All work here displayed has been designed and executed in the school from the raw material."

The teaching of art education at SAIC began informally in the 1880s. It was not until the 1930s that it became a distinct department. In 1934, the school announced that an arrangement made with the University of Chicago would allow SAIC students to take the academic courses necessary to qualify for a bachelor of fine arts. Further progress toward the goal of academic legitimacy was achieved when SAIC received accreditation from the North Central Association of Colleges and Secondary Schools in 1936.

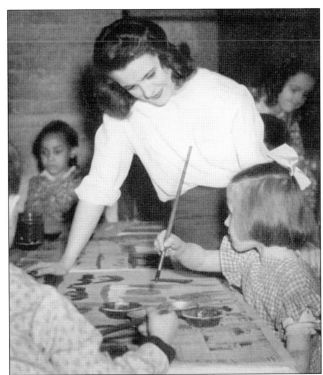

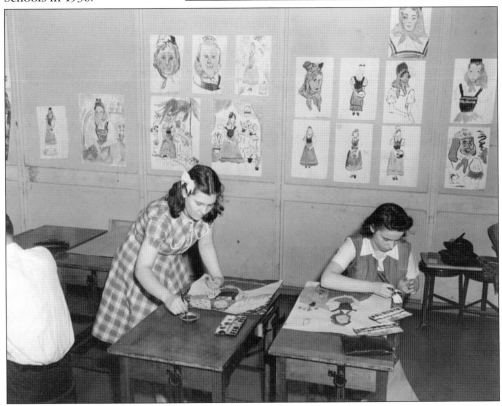

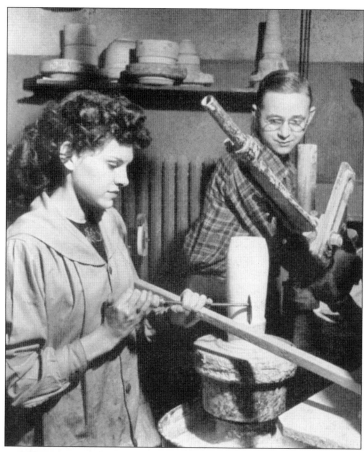

Ceramics and dress-design classes were part of the industrial arts division of the school. The 1936 school catalog notes, "With the increased attention now given to the work of American dress designers, the necessity for a sound course in this subject is apparent. The training offered in the School is planned to go beyond the routine dressmaking phase of the subject, and to develop a sense of originality, a feeling for line and texture, and a creative attitude toward style. The History of Costume naturally enters into this plan of study in its early phases."

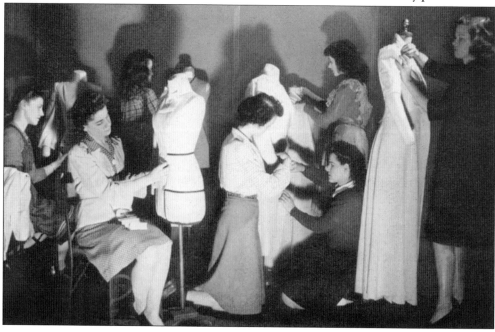

These pages from the 1945 school catalog depict industrial design drawing and lithography studios.

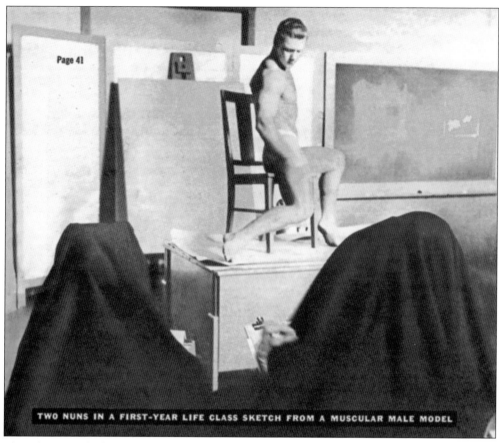

TWO NUNS IN A FIRST-YEAR LIFE CLASS SKETCH FROM A MUSCULAR MALE MODEL

This photograph, by SAIC instructor Kenneth Heilbron, was published in *Life* magazine as part of a double-page feature about the school in the May 23, 1938, issue. The story glibly drew attention to the two nuns pictured here and their attendance at a male figure drawing class. The nuns were almost forced to withdraw from the school, but Dean Norman Rice wrote a letter of apology to George William Cardinal Mundelein, and they were allowed to stay. Below is a life-drawing class from the same period.

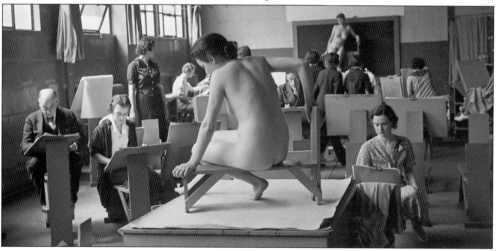

Looking southwest from the dockside along the Chicago River next to the Wrigley Building and close to the DuSable (Michigan Avenue) Bridge, students in an outdoor painting class enjoy the city's skyline.

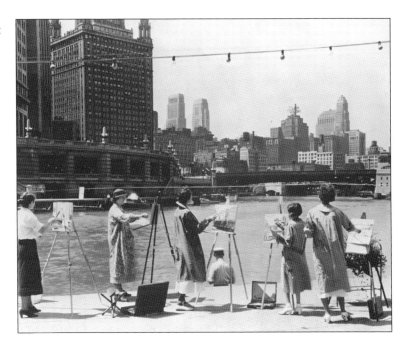

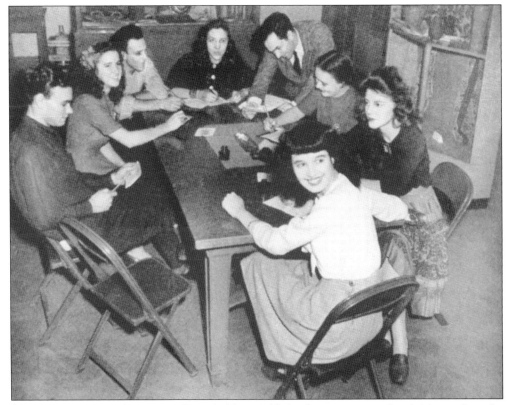

A meeting of the student council was held in 1944. Student groups and activities such as the student council shown here have always been a part of the student experience at SAIC.

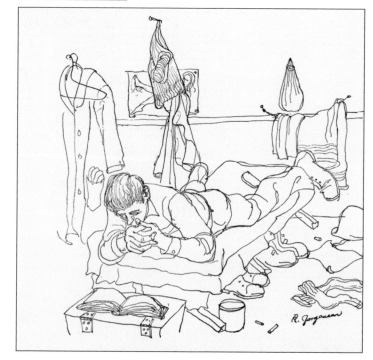

CRAYON AND CASQUE

Published occasionally by the Art Students' War Relief Association, of the Art Institute of Chicago

Vol. 1 CHICAGO, ILL., U. S. A., OCTOBER, 1918 No. 2

A ROADSIDE IN FRANCE
By LIEUT. HERBERT MORTON STOOPS

Courtesy of Red Book

Pictured here is the October 1918 issue of *Crayon and Casque*. In 1917, as a response to the United States' entry into World War I, the Art Students' War Relief Association was founded. It produced an occasionally published newsletter called *Crayon and Casque*, which carried news and information between those in military service and Art Institute students and employees.

This drawing is from the sketchbook of SAIC student Roger Jorgensen, who received his bachelor of fine arts in 1946. He served in World War II from 1941 to 1945.

At right is an illustration by student Eugene Kelsch from the 1925 yearbook *The Bronze Lion*, giving an insider's account of the student experience. Below, a drawing by Louis Ferstadt details his student experience. In October 1922, Robert Harsch (director of the Art Institute) sent a letter to alumni requesting information about their student and professional lives. This drawing was included in a nine-page fully illustrated letter from Ferstadt. Having studied at SAIC and Hull House in Chicago from 1918 to 1922, Ferstadt won a scholarship to the Art Students' League of New York, where he created murals at the RCA Building and the Eighth Street Station on the BMT Broadway Line. He became best known for his comic strip called *The Kids on Our Block*, published by the *New York Evening Graphic*. He also drew comics for the *Chicago Tribune* and the *Daily Worker*.

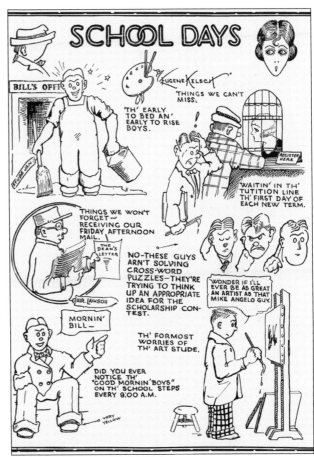

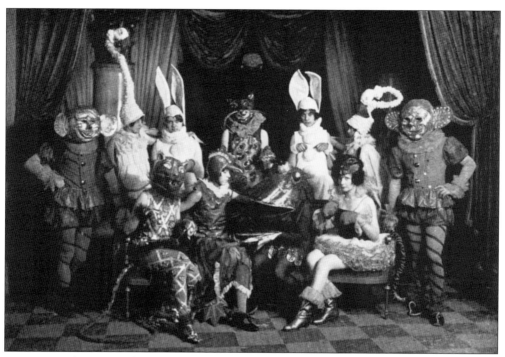

Here is another image from *The Bronze Lion* in 1925. The school was well known for its student balls and themed entertainments.

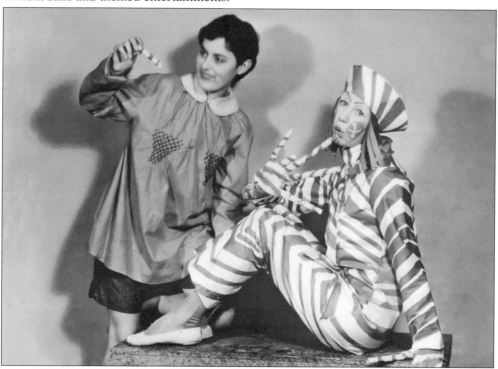

This 1923 image is from the Batik Ball. An annual event in the school's calendar, the masked ball featured prizes for the best costumes.

Four

1946–1960

In "On Painting in America, 1950," from the 1950 Exhibition Momentum catalog *A Forum: 9 Viewpoints*, Franz Schulze comments that "American art in 1950 is something governed by and dependent upon rich men—patrons—who are the only source of the money needed to nourish painting and music."

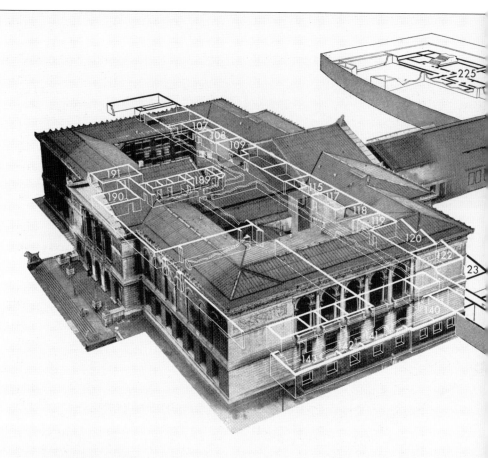

THE SCHOOL

The School of the Art Institute is a distinguished art school offering a choice of a wide variety of courses. It is staffed by foremost practicing artists and has the equipment for carrying out major projects in the fine arts, industrial art, advertising art, art education and drama.

In addition to the technical work carried on in the various studios, students benefit from intimate contact with the splendid collections of paintings, sculpture, decorative arts, prints and drawings housed in the Museum. History of Art courses supplement class lectures with research in the Ryerson and Burnham Libraries of Art and Architecture. Lectures, demonstrations, motion pictures and concerts given in Fullerton Hall and the performances in the Goodman Theatre are open to the student body.

The Art Institute of Chicago ranks as one of the country's greatest art museums, and many graduates of the School have received international recognition.

This double-page image from the 1945 school catalog offers a description of the school's standing and achievements, which in some respects are at odds with the expression of dissatisfaction articulated in the 1950 Exhibition Momentum catalog: "The birth throes are over. The task ahead is plain. We must reinvestigate our navels. What are we doing here, there?

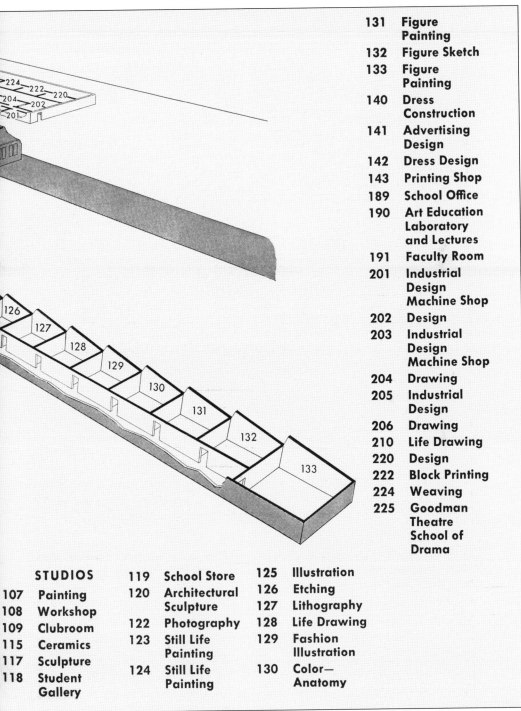

131 Figure Painting
132 Figure Sketch
133 Figure Painting
140 Dress Construction
141 Advertising Design
142 Dress Design
143 Printing Shop
189 School Office
190 Art Education Laboratory and Lectures
191 Faculty Room
201 Industrial Design Machine Shop
202 Design
203 Industrial Design Machine Shop
204 Drawing
205 Industrial Design
206 Drawing
210 Life Drawing
220 Design
222 Block Printing
224 Weaving
225 Goodman Theatre School of Drama

STUDIOS

107 Painting
108 Workshop
109 Clubroom
115 Ceramics
117 Sculpture
118 Student Gallery
119 School Store
120 Architectural Sculpture
122 Photography
123 Still Life Painting
124 Still Life Painting
125 Illustration
126 Etching
127 Lithography
128 Life Drawing
129 Fashion Illustration
130 Color— Anatomy

What are our roles? Our functions? What place do we occupy? What is Art? Its contributions to our society? More, what is society's contribution to art, our art? We must redefine ourselves . . . redefine, reinvestigate, and reintegrate," writes Aaron Roseman in "Manifesto," in the 1950 Exhibition Momentum catalog *A Forum: 9 Viewpoints*.

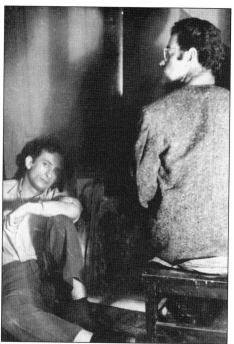

Leon Golub (left) is pictured here with Dominick Di Meo. After World War II, the Monster Roster—a group of predominantly SAIC artists—established a deeply existential and fiercely independent Chicago style that inspired many and has had a lasting impact on American art.

Visiting artist Roberto Matta is on the left. In the years following World War II, the school experienced a surge of energy. Attendance reached a record high, and the maturity and high level of commitment of students in this period greatly increased the quality and professionalism of the work being done. In *Over a Century* (1982), Roger Gilmore notes that Leah Balsham recalled, "The GI's had come back. A remarkably creative period was here. The students had an inner maturity, a certain strength of character. And they welcomed the fact that they were alive every day. It was a tremendous period, a tremendous sense of excitement."

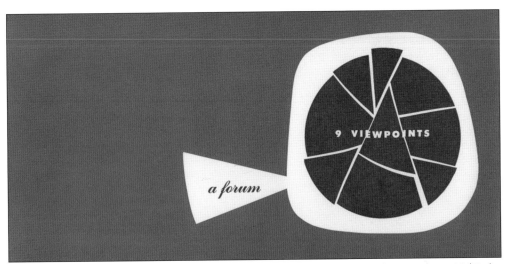

Pictured is the cover of the Exhibition Momentum catalog published in 1950. In 1947, the annual exhibition Chicago and Vicinity received a spate of unfavorable publicity for being too SAIC-centered and students from the school were excluded. A wave of protest began and the students produced their own exhibition. Exhibition Momentum declared itself to be "open to all artists of the local area to all media, to all art languages . . . to provide that universality of opportunity necessary to insure the vital movement of art."

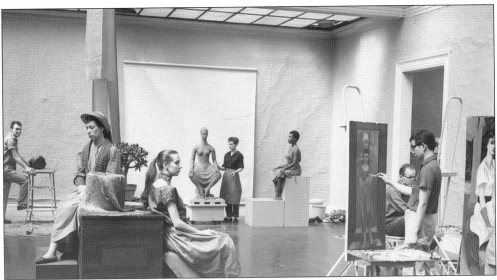

In this image, students make works on the second floor of the museum. An initiative devised by Dean Hubert Ropp for an exhibition called *SAIC 75th Annual: Art in the Making* was held May 8–24, 1954. Equipment such as throwing wheels, printing presses, easels, and looms was installed in the museum for demonstrations. The sculptor Cosmo Campoli (later an alumnus and faculty member) can be seen as a student on the far left.

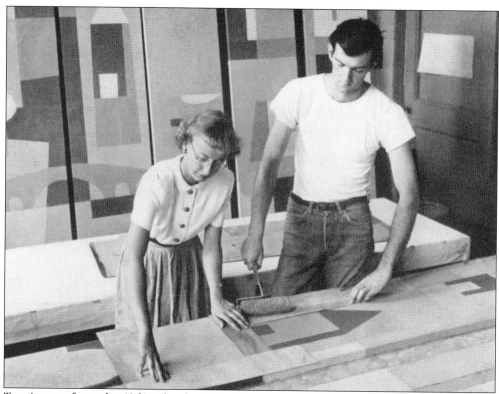

Two images from the 1960 school catalog show printing and weaving at a time of shifting material definitions. Printmaking was understood as a subarea of two-dimensional art and was included in the painting and drawing department, whereas pattern design was combined with weaving for the first time to form a new department. Previously, weaving had been offered only as a craft in the teacher education department, but during the 1950s, experiments were done with fabric sculpture and nonutilitarian hangings, so fiber-based practices were gaining recognition as art forms in their own right.

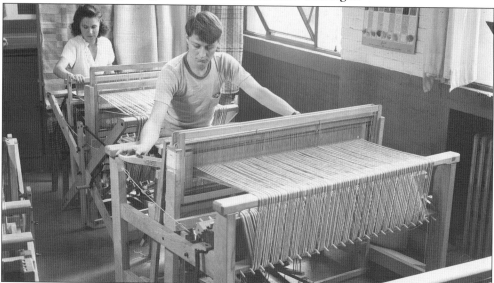

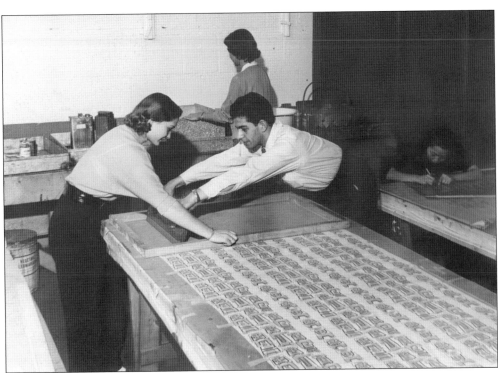

Also from the 1960 school catalog, these images show students engaged in fabric printing (above) and typesetting (below).

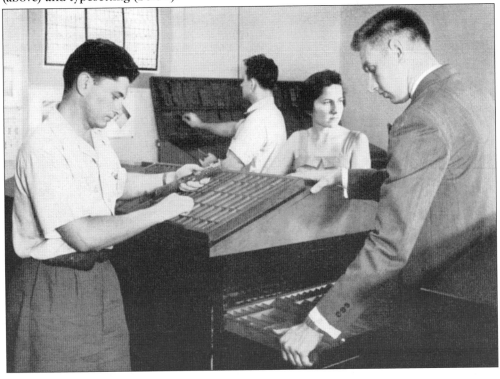

This photography class in 1959 is being taught by Harold Allen. Allen first came to SAIC to study in 1937, inspired by Helen Gardner's *Art Through the Ages*, which he read as a high school student in Blackfoot, Idaho. He worked with Gardner on producing the illustrations for her third edition, traveling to Europe during and just after World War II to photograph art and architectural examples. Over time, this has grown into a remarkable photographic record of Greek and Egyptian architectural styles and their influence on American vernacular.

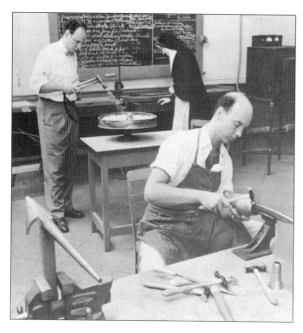

The metalcraft studio is seen here in 1954.

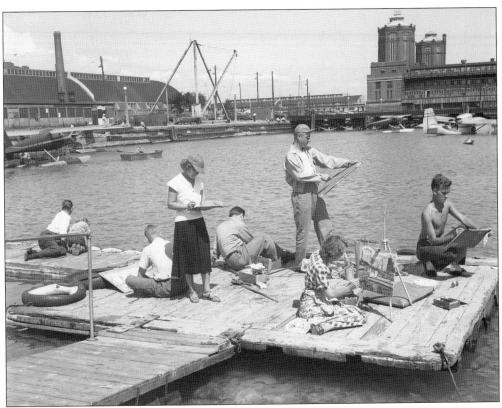

A painting class is in action on the docks near Navy Pier.

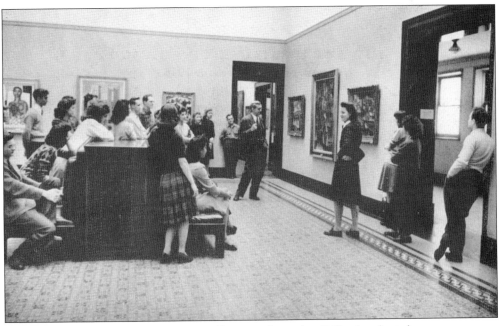

This image, *Picture Analysis in the Galleries*, is from the 1945 school catalog.

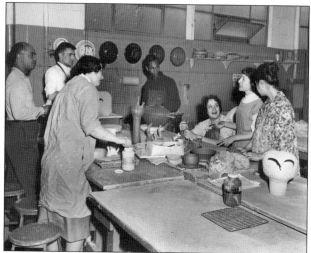

Leah Balsham (second from the right) was a student in ceramics at SAIC from 1935, receiving her bachelor of fine arts in 1940 and master of fine arts in 1947. She went on to lead the ceramics department, retiring in 1985, fifty years after her initial class enrollment.

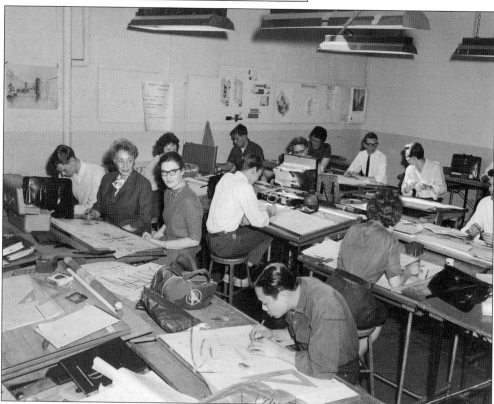

Marya Lilien, seen here second from the left, was the founder of the interior architecture department at SAIC, where she taught until 1967. Known affectionately by everyone as "Miss Lilien," she was born in Poland in 1900. Miss Lilien graduated from Lviv National Polytechnical Institute in 1927 with an engineering diploma, and then she became the first woman to apprentice with Frank Lloyd Wright at his Taliesin architecture school between 1936 and 1937, after which she returned to Poland. In 1941, she arrived back in Chicago for a second time, escaping Lviv, which was literally under falling bombs as the Russian and German armies advanced. Lilien died in Poland on January 12, 1998, at the age of 97.

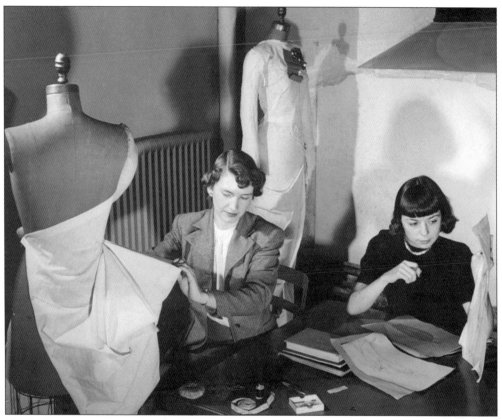

The fashion department has always offered a competitive, professionally relevant program. Along with its courses covering all aspects of the industry, the department has also included an annual fashion show to display the work of its students. The garments have been modeled by the fashion students, with the show always generating quite a bit of publicity.

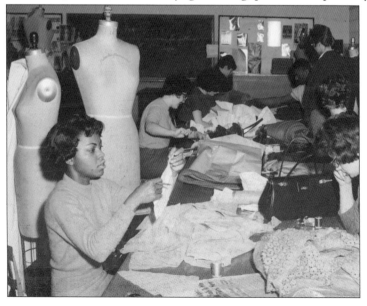

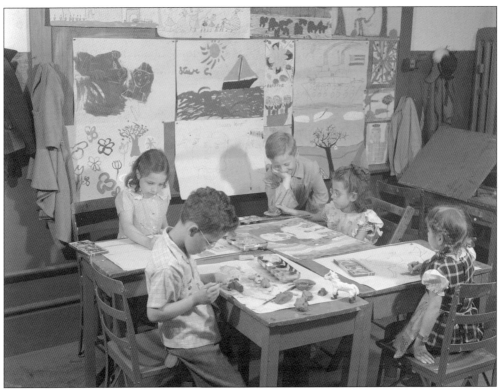

Children art classes have been a consistent feature of the institution. Many received their first introductions to art and artists in summer and weekend classes that were offered alongside the advanced classes and degree programs.

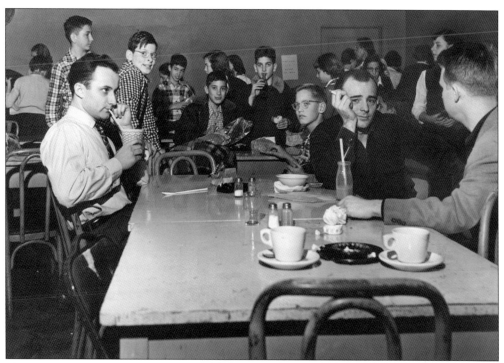

These 1955 pictures show the student lounge. Below clearly seen are artworks displayed on the walls down both sides of the room. In a recent interview, Jim Zanzi (an alumnus and faculty member) recalled how this was frequently the site of great arguments and lively exchanges between different groups of students. The atmosphere in the room was sometimes almost explosive. Zanzi explained, "I witnessed may times almost fisticuffs. They would have paintings from Ritman's class (Louis Ritman [1889–1963], a notable Romantic American impressionist) on one wall and then on the other wall would be abstract or non-objective paintings from another class. So these different groups of students were really going at one another. Once I saw somebody pull a painting off the wall. Then at the back of the room there was a corridor that led to the Goodman theatre, so the Goodman students would congregate at the back there," adding an altogether different dynamic.

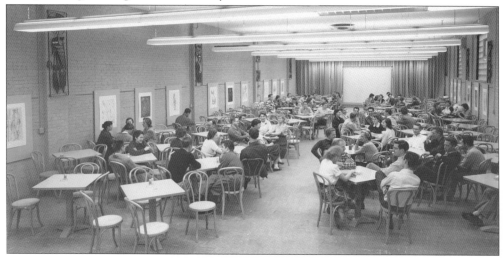

The SAIC Glee club is shown above in 1951, and below is an image of students showing kites they had made for a Kite Festival in 1957. Student clubs and groups came under the direction of an activities association composed of elected students from each class and with representation from all departments of the school.

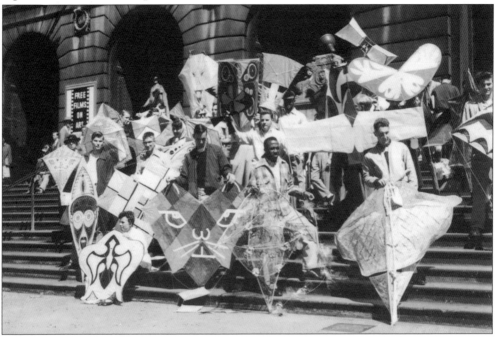

Five

1961–1975

In his 1982 book *Over a Century*, Roger Gilmore notes that according to alumna and faculty member Leah Balsham, "It's very hard, I think almost impossible, to convey the flavor of the School to an outsider. There's a kind of unanimity of purpose. And there's a peculiar kind of affection for this School that almost anyone who has gone to it manifests. It's really fantastic. . . . Most of one's contacts, teaching and otherwise, are on a one-to-one basis." This image shows the cover of the 1965 school catalogue.

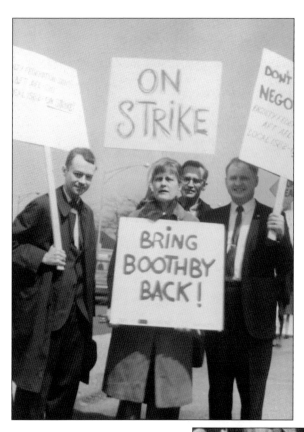

A series of protests, meetings, strikes, and boycotts was touched off in 1965 when the board of trustees forced the resignation of Dean Norman B. Boothby. In response to the strikes, the board announced it was willing to negotiate with an informal delegation of faculty members, and when the students received assurances that a student senate would be recognized, they called off their picketing on April 14.

Then, after 10 faculty members failed to receive contracts, faculty began to strike and picket again on April 24. The strike continued until April 30, when a settlement between the board and the faculty association was reached.

The Pakula Building is seen here in 1969. The school rented four floors of the building, located at 218 South Wabash Avenue, when a growing student population put pressure on existing accommodations. The printmaking department, graduate painting studios, various design studios, and a student gallery were located there from 1969 until 1976.

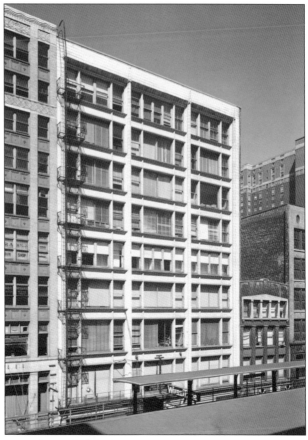

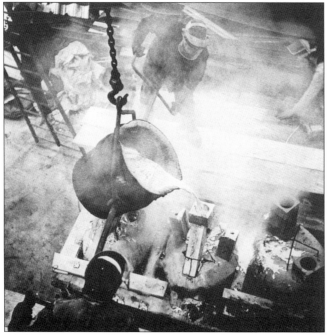

Faculty member Jim Zanzi is pictured with students working in the foundry in the late 1960s. Between 1965 and 1970, the school made substantial progress toward remedying the quality of physical facilities. New studios were created and equipped for photography, ceramics, and the foundry. The school was also air-conditioned for the first time.

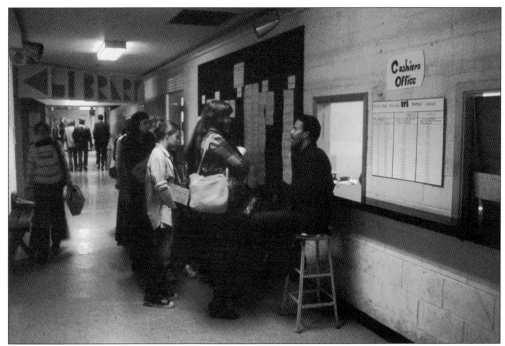

Students line up at the cashier's office opposite the school library. Until 1969, the library services were all provided by the museum's Ryerson Library.

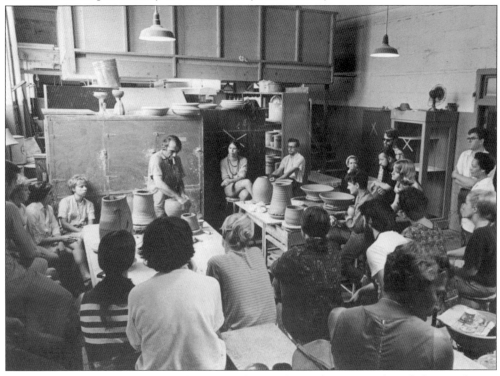

Pictured here is a ceramics classroom located on the east side of the Michigan Avenue building.

Student Roger Brown (at top) is seen with colleagues in Betsy Rupprecht's color theory class. Rupprecht's parents were among the group of benefactors who founded the Ox-Bow Summer School of Painting in Saugatuck, Michigan.

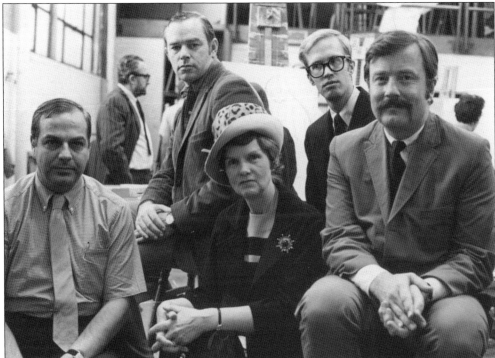

Donald J. Irving (second row, left) was director of SAIC from 1969 to 1982. In a 1978 interview, he talks about the importance of reciprocal teaching and learning: "Putting the student artist next to the professional artist so both can grow—that's what the training is all about. It's one-to-one contact between student and mentor, or learning guide, or role model."

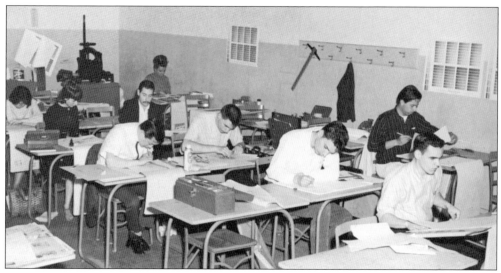

An advertising design class is pictured in session in the north wing of the museum in 1962.

John Kirtich (far left) and Tom Jaremba (facing the group) are seen with students in the Pakula Building. In 1973, environmental design and visual communication combined to make the design and communication department. The course offerings included a performance class taught by Jaremba, who created the performance department at SAIC and had previously taught dance and choreography classes at the Goodman School of Drama.

A painting studio is pictured at right, and below is a film and audio editing suite. As a self-study prepared by the school in 1972 states, "The School is still in the process of gradual transformation from a beaux-arts professional school with a distinct product orientation to a school utilizing visual disciplines, art history, and the humanities as a referential core from which students may draw the quality of experience they need to become creative human beings."

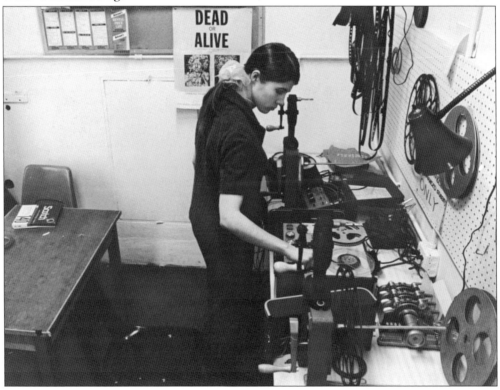

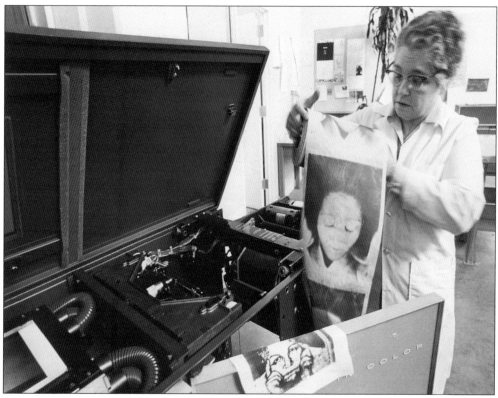

Sonia Sheridan is shown here with the 3M Color-in-Color copy machine, and below is the Generative Systems studio. Sheridan came to the school in 1961 to teach printmaking and foundation classes. In 1970, she had the opportunity to work with 3M to use its newly developed Color-in-Color copier. Sheridan began to teach a groundbreaking course that she called Generative Systems. The name Generative Systems became associated with a range of early digital art making and video activities, creating the foundations for the school's Department of Art and Technology. (Both, FDL.)

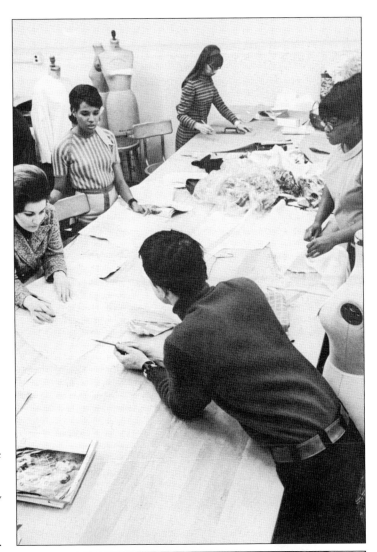

In 1969, the school dropped the system of declaring a major, with the exception of required liberal arts, art history, and two drawing courses. After consultation with faculty advisor, students were now able to determine his or her own curriculum. This change opened the way for interdepartmental experimentation and cross-curricular teaching.

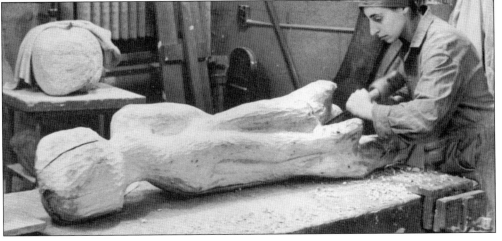

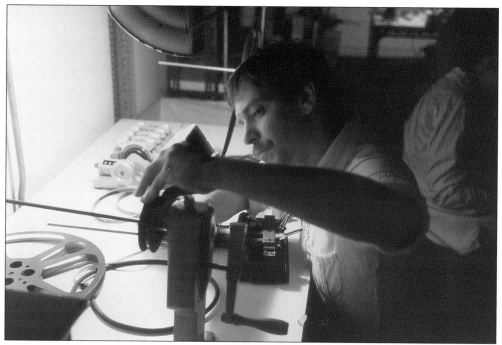

Here, a student edits in the film department. In 1966, Gregory Markopoulos, a noted avant-garde filmmaker, came to the school to start a filmmaking program under the aegis of the photography department. That program quickly grew to include animation and video.

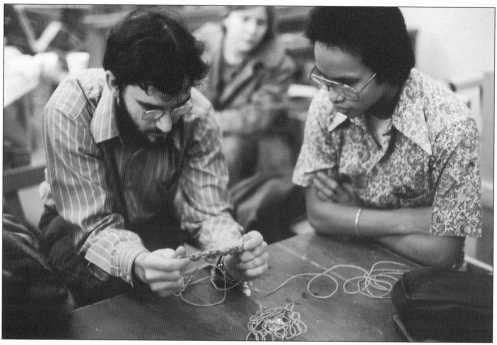

Students are exploring structure development in the fiber department.

Georgia O'Keeffe is seen here during her 1967 visit to receive an honorary degree from SAIC. John Duncan, director of admissions, is at left, with Dean Roger Gilmore and O'Keeffe.

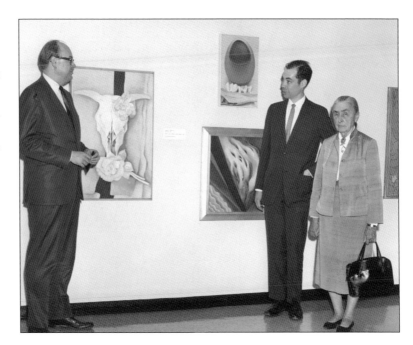

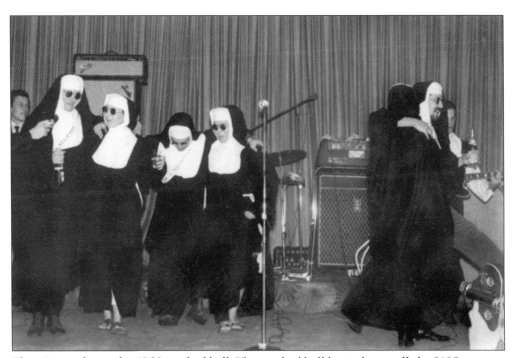

The picture shows the 1968 masked ball. The masked ball hosted annually by SAIC was one of the features of the cultural calendar of the city for over five decades.

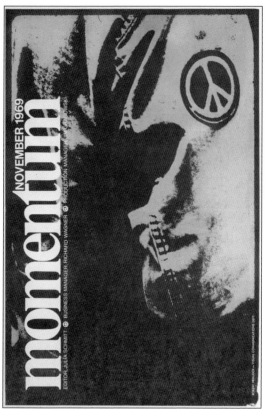

Pictured here is the November 1969 cover of *Momentum*, the student news publication. In his 1982 book *Over a Century*, Roger Gilmore writes that Tom Kapsalis, a former student and faculty member, said, "And then, there was a period I think where students wanted to do their own thing. In the 60s everyone was rebelling And I think that that was a strange period. It was something that was good for us to go through."

By 1970, the school had a dean of students, a nurse, a financial aid officer, a work placement service, and for each of the school's fields of study, departmental and divisional chairpersons who were responsible for the faculty and the curriculum.

Above is the school cafeteria as it appeared in 1965. Below, a photograph from 1975 shows the student lounge, which is also pictured in the image on page 67 from 1955.

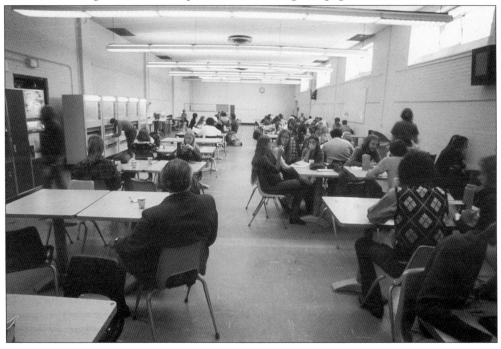

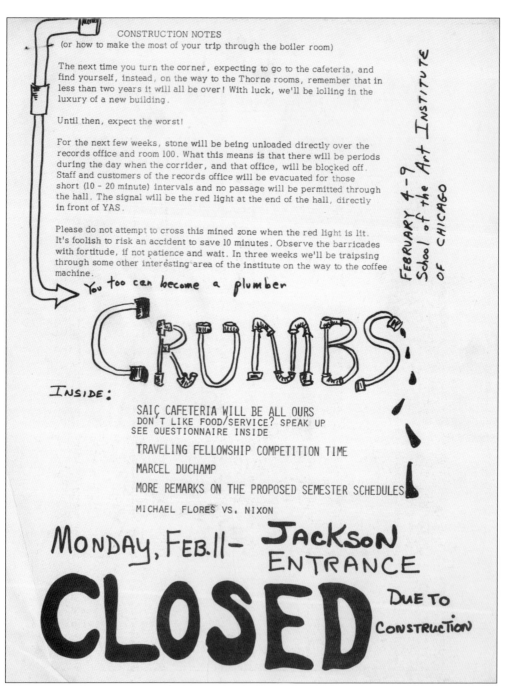

CONSTRUCTION NOTES
(or how to make the most of your trip through the boiler room)

The next time you turn the corner, expecting to go to the cafeteria, and find yourself, instead, on the way to the Thorne rooms, remember that in less than two years it will all be over! With luck, we'll be lolling in the luxury of a new building.

Until then, expect the worst!

For the next few weeks, stone will be being unloaded directly over the records office and room 100. What this means is that there will be periods during the day when the corridor, and that office, will be blocked off. Staff and customers of the records office will be evacuated for those short (10 - 20 minute) intervals and no passage will be permitted through the hall. The signal will be the red light at the end of the hall, directly in front of YAS.

Please do not attempt to cross this mined zone when the red light is lit. It's foolish to risk an accident to save 10 minutes. Observe the barricades with fortitude, if not patience and wait. In three weeks we'll be traipsing through some other interesting area of the institute on the way to the coffee machine.

You too can become a plumber

FEBRUARY 4-9
School of the Art Institute
OF CHICAGO

CRUMBS

INSIDE:

SAIC CAFETERIA WILL BE ALL OURS
DON'T LIKE FOOD/SERVICE? SPEAK UP
SEE QUESTIONNAIRE INSIDE

TRAVELING FELLOWSHIP COMPETITION TIME

MARCEL DUCHAMP

MORE REMARKS ON THE PROPOSED SEMESTER SCHEDULES

MICHAEL FLORES VS. NIXON

MONDAY, FEB.11— JACKSON ENTRANCE
CLOSED DUE TO CONSTRUCTION

This cover page is from the February 4–9, 1974, issue of the student newsletter *Crumbs*. This issue articulates a common conundrum of keeping the school running while rebuilding it as well as the needs to update the student facilities, especially the food service. The newsletter announces a new approach: "With hope, enthusiasm and some trepidation we have decided to sever our relationship with the food service in the museum and strike out on our own." Students formed a cooperative cafeteria committee with the function of advancing their needs and affecting the developments of new facilities.

Six

1976–1989

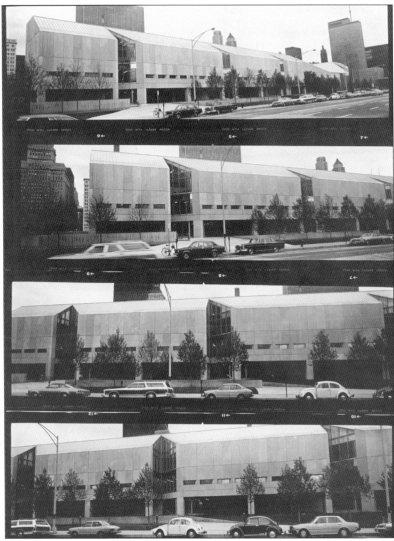

Kate Horsefield, cofounder with Lyn Blumenthal of the Video Data Bank, received her master of fine arts in 1976. As quoted in Roger Gilmore's *Over a Century* (1982), her words characterize the prevailing atmosphere of the school at that time: "The new subjectivity of the feminist movement demanded that its followers analyze power relations between the genders and how institutional structures enforce gender inequality or support economic or other forms of gender-biased exploitation . . . working towards an expanded democracy that allowed greater equality and participation for all subjects, no matter what their color, gender, or class." This image shows the cover of the 1977 school catalogue.

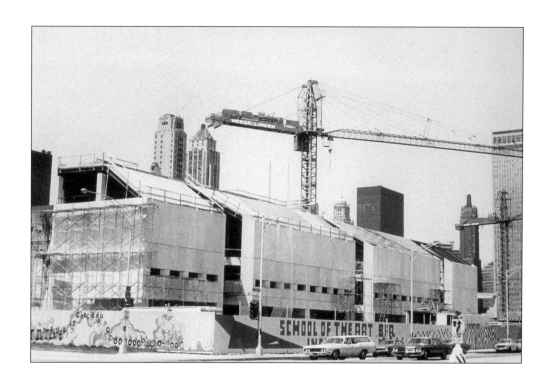

Seen above, the Columbus Drive building is under construction in 1971, and below is a plan of the first floor. While sharing the block with the museum, the new building gave the school new facilities, a distinct identity, and a new east-facing entrance on Columbus Drive.

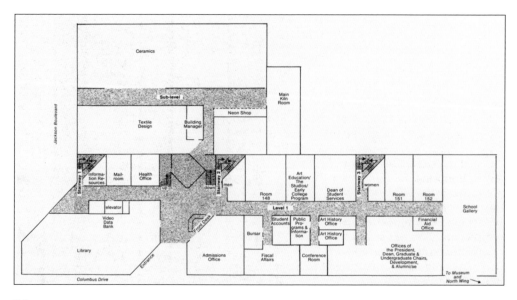

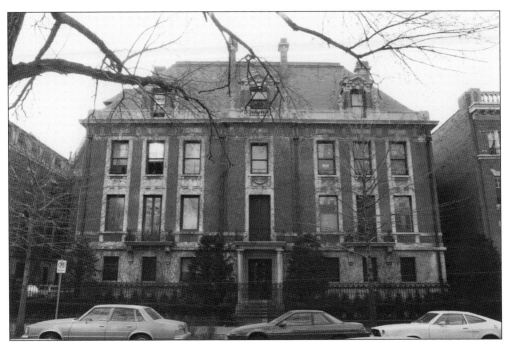

In the fall of 1984, SAIC acquired the Playboy Mansion, through a combined donation and purchase agreement, as a residence hall for students and visiting faculty. *Playboy* magazine was a long-standing supporter of artists in Chicago. Hugh Hefner, the proprietor, was committed to commissioning Chicago artists as illustrators for the magazine and, consequently, the early careers of many who studied at the school were supported in this way.

The Film Center at SAIC opened in 1972 in the Columbus Drive Auditorium. In 2000, it moved to 164 North State Street and was renamed the Gene Siskel Film Center, honoring the late, nationally celebrated critic. The role of the film center in the school and in the city has been significant as an international film venue committed to screening trailblazing work by independent filmmakers alongside art-house classics.

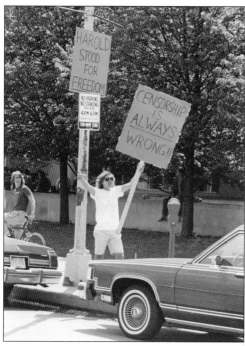

Pictured here are demonstrators on Columbus Drive on May 11, 1988. A public outcry arose regarding a painting by David K. Nelson Jr. (a graduate of SAIC in 1987). The painting, called *Mirth & Girth*, was displayed as part of an exhibition to showcase nominations for the annual Traveling Fellowship competition. The painting depicts the then recently deceased African American mayor of Chicago Harold Washington dressed in women's undergarments. (Photograph by Michael Fryer, CT.)

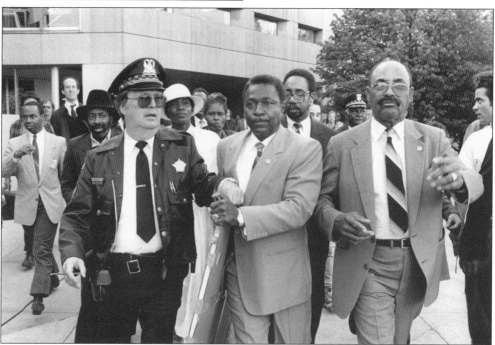

City aldermen accompanied by a police officer are seen here removing David Nelson's painting from the school. Following a complaint, city aldermen arrived at SAIC to demand David Nelson's painting be taken down. The request was refused, and they removed the painting themselves. A public demonstration developed along Columbus Drive, and a protracted legal battle ensued. In 1994, with the assistance of the ACLU, Nelson won on the basis of First Amendment rights. (Photograph by Val Mazzenga, CT.)

The print studio looks onto Columbus Drive in March 1989, as demonstrators gather in front of the school entrance for the second time that academic year. An exhibition organized by SAIC's Black Student Association included an installation by Dread Scott (who received his bachelor of fine arts in 1989), called *What is the Proper Way to Display the US Flag?* Conceived as part of an antiwar debate, the work included an American flag displayed on the gallery floor and pictures of flag draped coffins returning from war. The artwork created ripples of heated debate worldwide about the use of the US flag in an artwork. The upset reached Congress and brought the artist before the Supreme Court on First Amendment issues. This photograph from February 27, 1989, is by Marianne Scanlon, an alumna of the photography department. It was donated to the institutional archives in 2014.

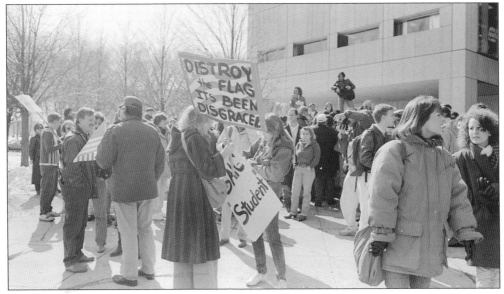

Students from the fiber and architecture departments are seen creating their work.

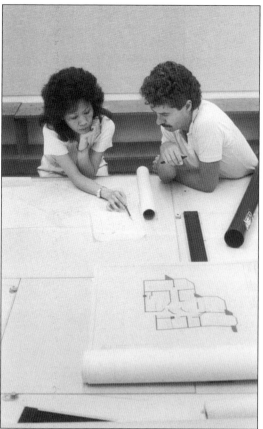

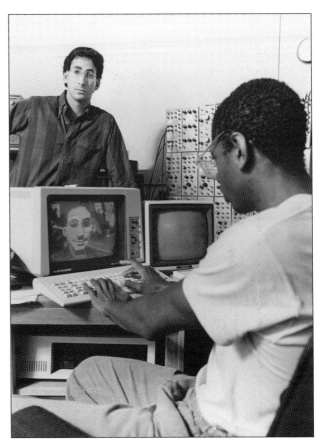

Pictured at right is the studio for the Generative Systems class, the name of which was later changed to Art and Technology. Below, students learn how to edit 16-millimeter film in the film department.

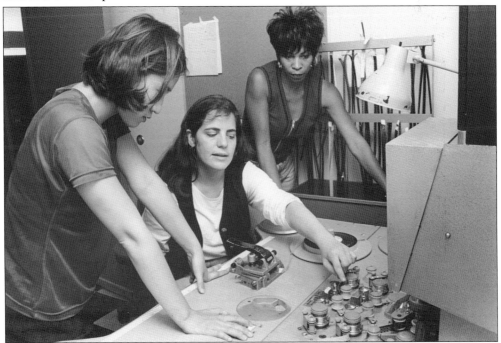

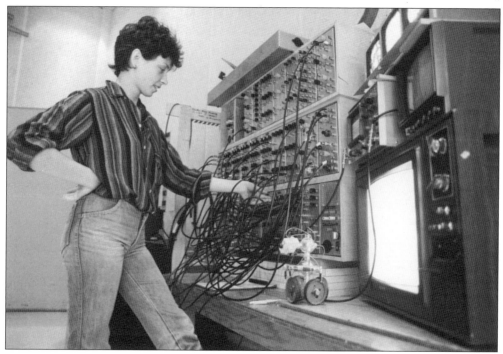

Here, a student works with the Sandin Image Processor. Dan Sandin developed his Image Processor (IP) between 1971 and 1974. It functions as a kind of analog video synthesizer that alters and modulates image output signals. The IP is still an actively used resource.

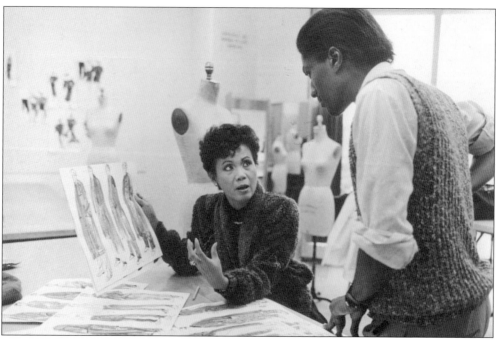

This picture was taken during a fashion illustration advising meeting.

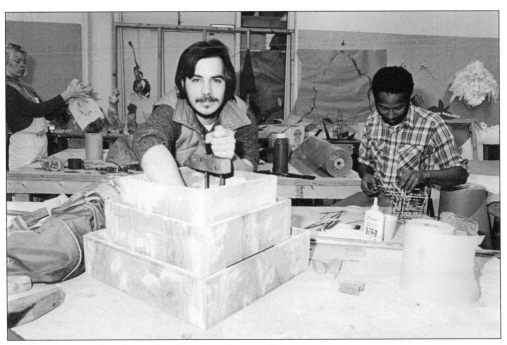

Students cast and make molds in the sculpture department.

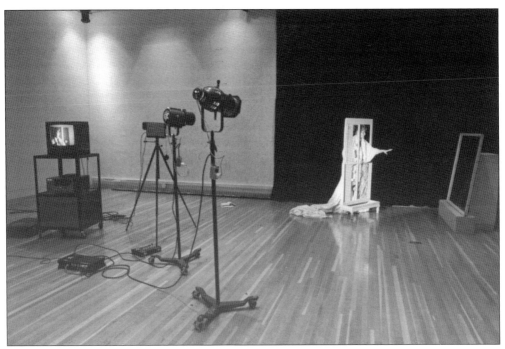

Seen here is the performance department. Students had been performing at SAIC for some time before the department was created. The growth in live and time arts at this time was a significant feature of a fast developing contemporary art world. The school was again responsive to new approaches and ideas. By the 1980s, the performance department would become a leader in its field.

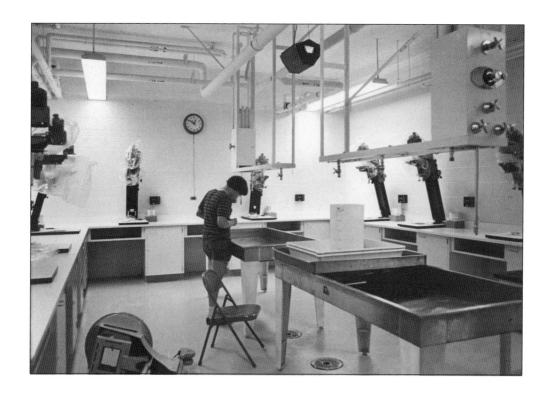

The Columbus Drive darkroom upon opening is seen above, and below is a new photography studio facility. The photography facilities allowed the department to grow in stature and range.

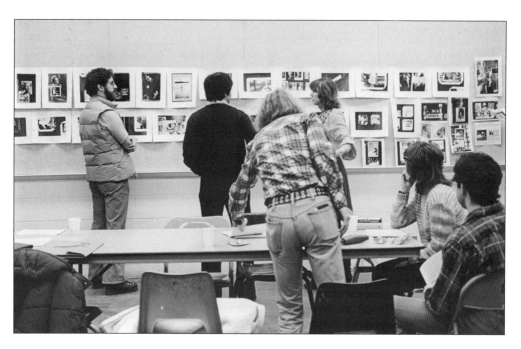

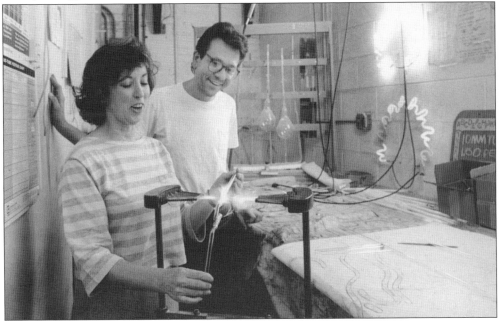

An experimental video studio is seen at right, and the neon shop is pictured below in the 1970s. The new facilities of the Columbus Drive building allowed for more interdisciplinary and experimental work to develop. Studios and technical shops like the ones depicted here offered opportunities for students to work with formal and conceptual approaches.

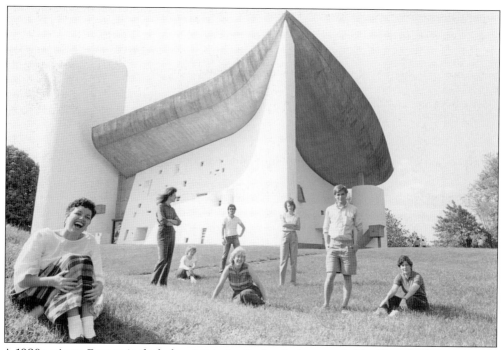

A 1980s trip to France included a visit to Le Corbusier's remarkable Chapel of Notre-Dame du Haut in Ronchamp, France. Study trips are a regular feature of the SAIC calendar and have been offered from the earliest times of the school.

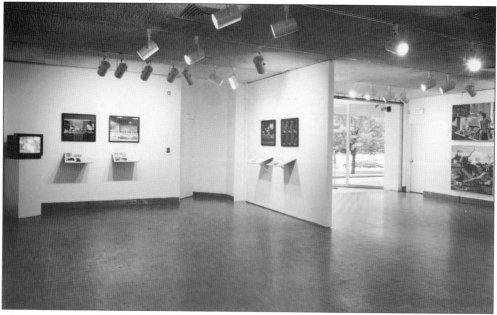

This image shows the first-floor gallery in the Columbus Drive building. A commitment to student exhibitions at SAIC is demonstrated in the designation of this key space in the new building.

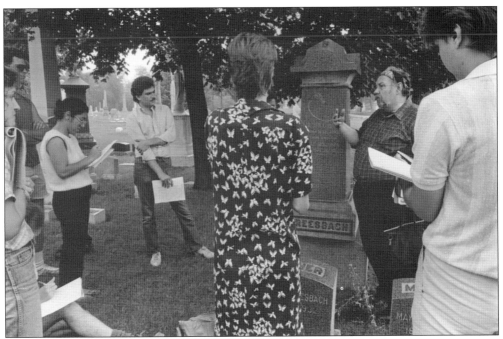

Robert Loescher (1937–2007) is pictured here delivering a walking lecture tour of Graceland Cemetery in Chicago. Loescher taught at SAIC from 1972 to 2006 and served as chair of the Art History Department. During his tenure, Loescher renamed the department, formerly Art History and Aesthetics, to Art History, Theory, and Criticism. In 1990, King Juan Carlos I of Spain knighted Loescher in honor of the educator's contributions to the dissemination of Spanish culture.

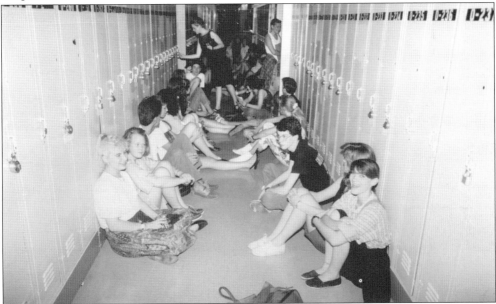

This image depicts a typical scene in the Columbus Drive basement hallway in the 1980s. The school was bustling and overcrowded. The majority of the school was all located in one building and students conducted their daily activities wherever they could find space.

The school store pictured here was located at the southeast corner of the Columbus Drive building. For many years, the school art supply store was an important feature of the school, at a time when there were no other art supply retails in the area. The store was closed in 1988 and subsequently managed by an outside vendor.

Students are pictured in the center stairwell of the Columbus Drive building overlooking the sculpture courtyard.

Seven

1990–2016

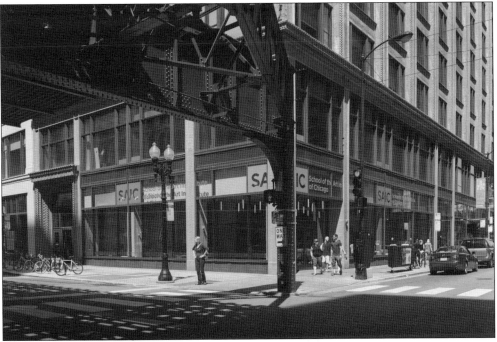

In "Trust, Construction, Digestion," from *School Book 1,* Lin Hixson, instructor in the performance department, points to the prevailing questions of recent decades when she writes: "Diversity, participation and imagination form the meeting place of our understanding. By coming together with these ingredients, we give the body its health; we provide for its growth; we determine its survival." (KGP)

The Lakeview Building and the MacLean Center (at 116 and 112 South Michigan Avenue respectively) are pictured at left in 2005, and below is the Sharp Building (37 South Wabash Avenue). During the early 1990s, SAIC expanded once more, back across Michigan Avenue and acquiring multiple properties. This period represents some of the most significant growth in the school's history. On the northeast corner of Wabash Avenue and Monroe Street, located in the historic John B. and Alice R. Sharp Building, is the LeRoy Neiman Center. This is the first dedicated campus center in the school's history, housing student amenities that include street-level gallery space, a café, lounge, and meeting areas for student government and other student-led organizations. The gifts from alumni LeRoy and Janet Byrne Neiman to SAIC and its affiliated Michigan-based school Ox-Bow collectively total $9 million, making them the most generous alumni in SAIC's history. (Both, KGP.)

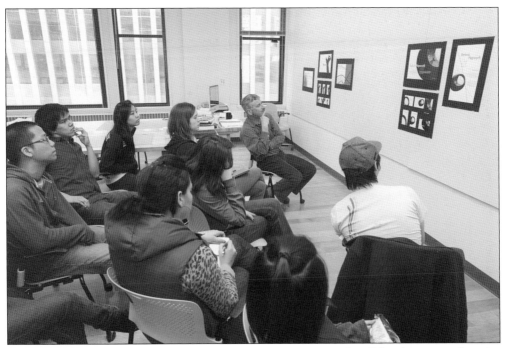

The school continues to reinvest in its programs, represented well by the comprehensive remodeling and reconfiguration. The renovation of the visual communication design department is typical of this reinvestment.

There is a strong commitment in an undergraduate curriculum to the liberal arts. The science lab and classroom expansion, completed in 2013 and shown here in the Lakeview Building, demonstrate this.

Expansions in contemporary design degree programs, including architecture and the designed object, took form in a new department called AIADO: Architecture, Interior Architecture, and Designed Objects, located in the landmark Carson-Pirie-Scott Building, currently the Sullivan Center, designed by Louis Sullivan in 1899. Also located in this building on the Wabash Avenue side are teaching and studio facilities, which were constructed to accommodate the growing fashion body and garment degrees and the Fashion Resource Center.

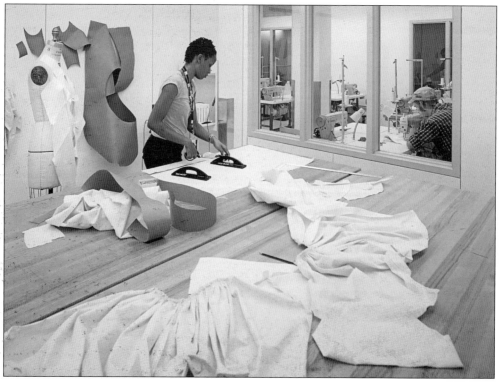

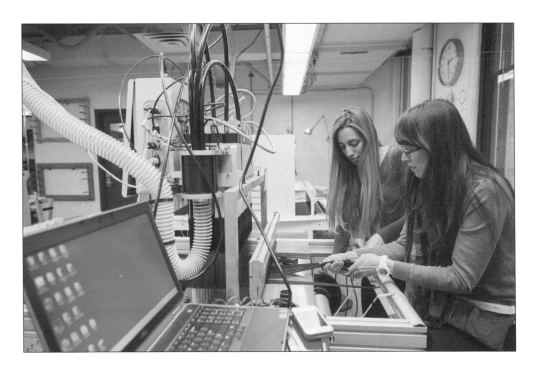

From the 1990s on, the impact of digital facilities transformed many parts of the school. Pictured above are digital Jacquard looms located in the fiber and material studies department. Pictured below is the digital lab of the photography department, renovated in 2008. (Below, KGP.)

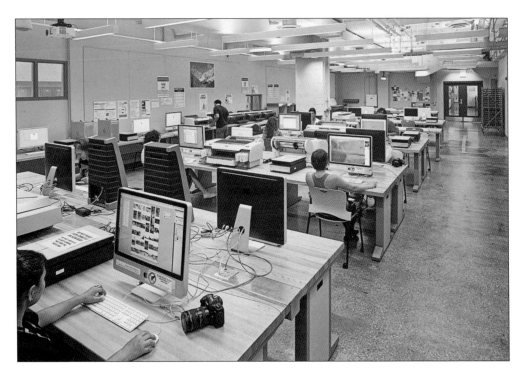

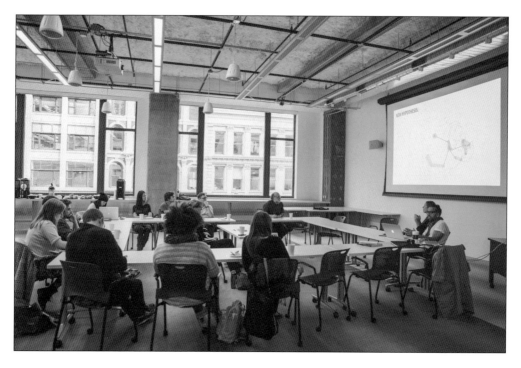

The past three decades have seen the growth in master study programs at SAIC. Masters degrees in Arts Administration and Policy, New Arts Journalism, Visual and Critical Studies, and Writing now offer a range of academic contexts complementing and extending the studio programs.

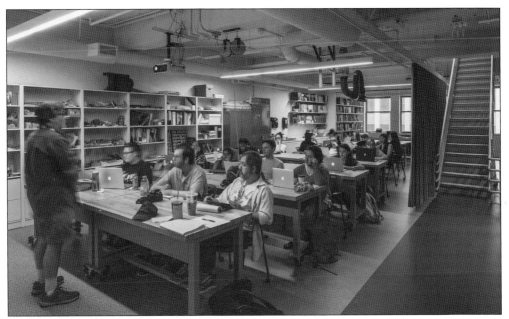

The historic preservation department facilities include a classroom (seen here), design studio, a conservation and materials laboratory, lecture space, a resource library, and a student lounge. Its curriculum is focused on the revitalization of the built environment through the comprehensive exploration of science, history, creative arts, politics, and technology. (KGP.)

The Department of Art Education has a long-standing commitment to preparing educators as critical citizens who value egalitarianism, cultural difference, democracy, and social justice. Students are depicted here working at Homan Square through an incubator project bringing together public schools on the west side of the city with local garden groups and local artists.

The Department of Art Therapy emerged from a growing interest in psychology in the arts. In the 1970s, under the guidance of Don Seiden, a class in clinical psychology lead by Irving Millstein was created. By the mid-1990s, art therapy at the school had quickly grown into a thriving masters program.

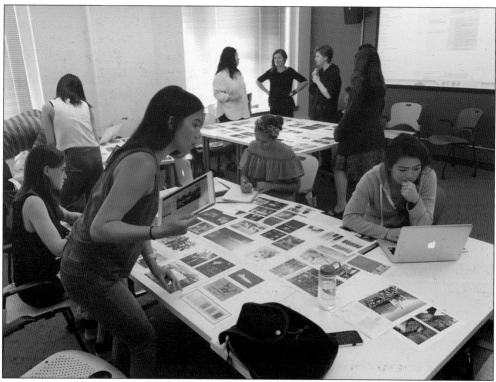

Students in an arts administration class engage in a curatorial exercise. The master of arts in Arts Administration and Policy was initiated in 1995 by Peter Brown, then SAIC's senior vice president, who saw the need to facilitate the next generation of arts leaders. The curriculum has evolved to include developments in cultural management, integrating forms of service learning through a "Management Studio," with an engaged criticality that both produces and is formed by cultural policy.

The Flaxman Library is in the Sharp Building. John Flaxman graduated in May 1988, tragically passing away a few months later. The John M. Flaxman Library was dedicated in his honor in 1989, with a generous gift from the Flaxman family. The main floor of the library was renovated in 2013, repositioning the library as a center for interdisciplinary teaching and learning and recognizing the importance of technology in scholarly research. (HBP.)

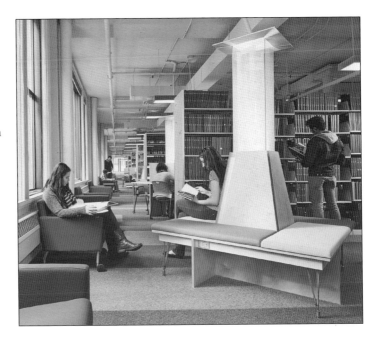

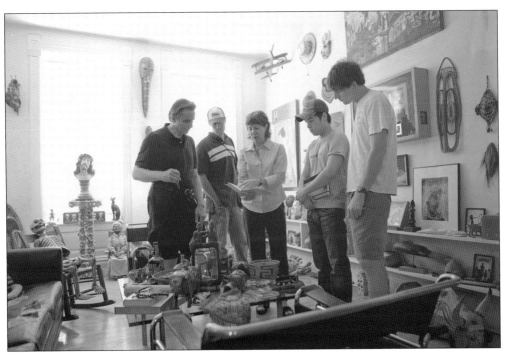

A research studio class engages with the objects at the Roger Brown Study Collection. A commitment to hands-on learning experiences has informed resources at the school throughout its long life. Amongst these important resources are the school's libraries, archives, and collections. The Flaxman Library, Fashion Resource Center, Roger Brown Study Collection, Video Data Bank, and Joan Flash Artists Book Collection offer student work opportunities alongside class-based activities.

The chalkboard reads:

DESIGNERS: NEVER WORK OFF THE DESKTOP

WISH LIST
IN-HOUSE AD FOR INK
ADVERTISE BLOG
MENTION EXTRAS ON WEB

quotes
articles
poems

Italics
book titles
journal titles
names of art pieces
art exhibitions
films + plays

FOR REVIEWS:
- TITLE OF EXHIBITION
+ ARTIST AS HEADLINE
PRECEED ARTICLE W/EXHIBITION
INFORMATION IN ITALICS

Caption
7pt schoolbook
Bold

CLASSIFIED ADS NEWS
TECHNOLOGY

SAIC has a long history of student publications. The most notable contemporary example is *F-News*.

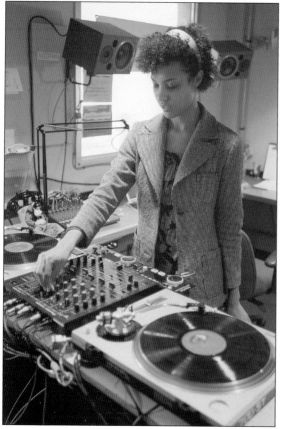

Students have a keen interest in broadcast media. Student activities include SAIC Free Radio and Ex-TV.

This is an interior shot in the 162 North State Street residence hall, which was opened in 1999. There was a tremendous growth in the student population at that time, and SAIC was now able to offer a comfortable live-work environment for students.

The Office of Campus Life coordinates an active campus fueled by student groups, organizations, and leadership opportunities with more than 60 student groups and organizations and a full schedule of events. Sustainable SAIC, pictured here, is one of the groups.

Students are seen at the LeRoy Neiman Center opening celebration in Fall 2012.

The LeRoy Neiman Center offers a lively social and meeting space for the community in the lower two floors of John B. and Alice R. Sharp Building.

The Sullivan Galleries, seen here, delivers a year-round program that includes student thesis exhibitions produced through student work-study, class projects, and curatorial appointments. For more than 25 years, the location of the school's galleries was off campus, and then in spring 2008, the school opened this 23,000-square-feet-gallery on the seventh floor of the Sullivan Center, at 33 South State Street, bringing this important activity back to campus.

Located in the LeRoy Neiman Center and the Columbus Drive building, the Student Union Galleries (SUGs), founded in 1994, is a student-managed organization dedicated to the exhibition of student work.

The SAIC Ballroom, at 112 South Michigan Avenue, is located in the former Illinois Athletic Club building. The ballroom hosts many school activities year-round, such as the semiannual student art sale.

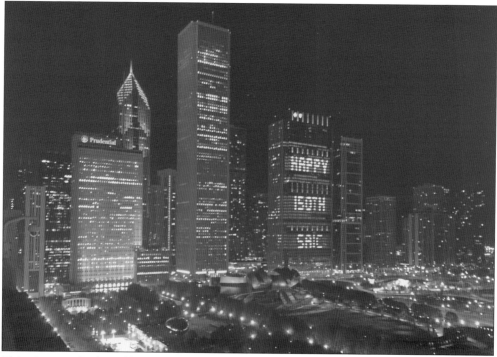

This view overlooks Millennium Park from 112 South Michigan Avenue. Anniversary wishes light up the Blue Cross Blue Shield Tower on the night of SAIC's 150th anniversary gala.

110

Eight

AFTERWORD

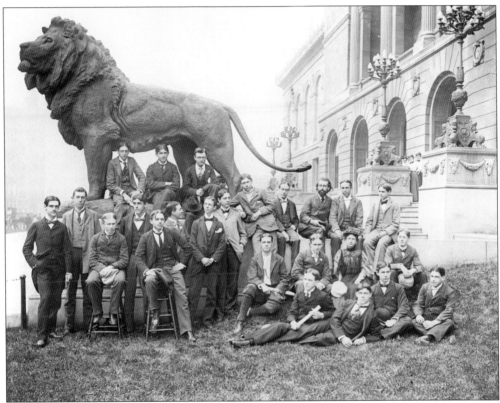

Shown here is the class of 1896 posed on the southeast corner of the Art Institute of Chicago. In this excerpt from *The Subversive Imagination: Artists, Society, & Social Responsibility* (Routledge 1994—almost 100 years after this image was taken), Carol Becker, who served as dean from 1994 to 2007, points to flexibility, reflexivity, and resilience as key to understanding what characteristics an artist might require: "Being an artist is finally a sociological construct in all its material, psychological, and spiritual dimensions. There has been so little understood of this, almost no thought as to how artists live—sustain themselves economically, emotionally, creatively, and sexually; make personal and aesthetic choices; develop intellectually; take political stands; hover between realities; and survive in prison, exile, under dictatorships, capitalism, or within revolutions."

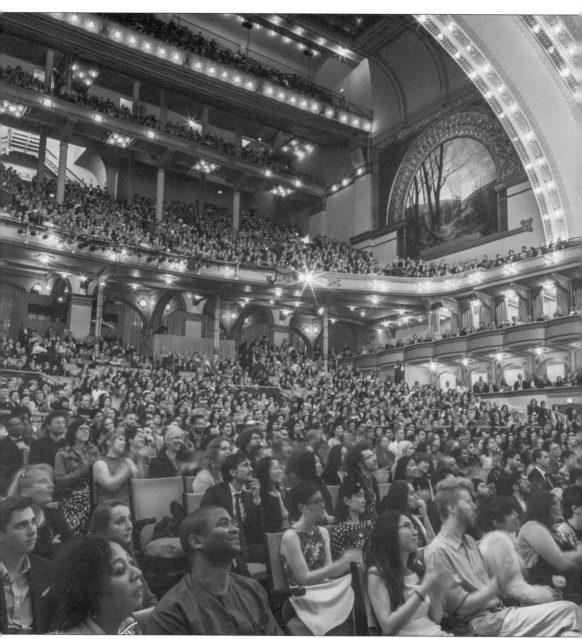

The class of 2016 is seen at commencement in the remarkable Louis Sullivan–designed Auditorium Theatre in Chicago. This final chapter takes SAIC's core values as a lens through which to read the archive. SAIC's articulation of its core values has emerged as an expression of a shared experience of the school in the present time. This publication represents a small part of what has been an extensive examination of the archival documents. The authors found many examples that appear to express a long-standing commitment to the same ideas. This chapter continues to offer an illustration of these values as a means of reflection. SAIC's values are stated as follows: "we are explorers; meaning and making are inseparable; we are both artists and scholars; we make history; we are Chicago."

"WE ARE EXPLORERS"

The school's commitment to an open structure is embodied in a curriculum of self-directed study within and across a multiplicity of disciplines and approaches that promote critical thinking, rigorous investigation, and playful creativity. Through interdisciplinary practices and in deeply focused media, faculty and students conceive and accomplish exchanges in cultural study, production, and research with artists and scholars around the world. The school is a community that challenges the notion that any field is ever beyond rediscovery. Beloved faculty Barbara DeGenevieve (second from the left) exceeded boundaries in life and in teaching.

The Artist in the Landscape summer study trip, led by Jim Zanzi and Lisa Stone, occurred annually from 1986 to 1998. Adjunct faculty member Jerry Bleem (who received his master of fine arts in 1992) is shown right of center when he was a student. Explorations through the Upper Midwest occurred so students could experience exceptional examples of the built and natural landscapes. This class photograph was taken in front of the Gambrinus statue at the G. Heileman Brewing Company in La Crosse, Wisconsin, in 1991.

A feature of the decades around the turn of the 21st century has been curriculum developments that have embraced a broad definition of artistic practice. John Kurtich is pictured here on one of many occasions when he personally prepared and delivered a meal for his students as part of a class.

SAIC has developed its interactions between the arts and sciences. Bringing new faculty into the school has facilitated a bridge between disciplines.

A game-based visualization presentation exhibited as part of the *Data Viz Collaborative* exhibition at SAIC's Neiman Center during the spring of 2016. Students and faculty from Northwestern University and SAIC collaborated on a series of experiments in visual communication design. Contributing to SAIC's long history of connecting art and science, the *Data Viz Collaborative* was developed as a course that involved creative approaches to information visualization.

"Meaning and Making Are Inseparable"

At SAIC, students and faculty believe that meaning and making are inseparable, existing as a perpetual and productive cycle driven by experience, research, and critique. The school's commitment to a wide range of media and processes supports our assertion that the artist, designer, scholar, and writer are uniquely qualified as makers to provide leadership, creative perspective, and hands-on skill for shaping today's world, as well as contributing to its opportunities. Critique, as a fundamental component of the creative process, provides assessment as well as new ideas, possibilities, and directions that enable the community to sustain argument, rigor, experimentation, playfulness, invention, subversion, and mutual respect. Pictured from left to right are instructor Robert Skaggs, noted painting faculty member Ray Yoshida, and former dean Roger Gilmore.

Many visiting artists feature in the school's long history. Above, Claes Oldenburg (left) stands beside faculty member Whitney Halstead. The image below shows artist David Hockney (right) during his 1984 visit. Conversations between studio and classroom have always been fluid at SAIC. The Visiting Artists Program (VAP) was founded in 1868 and is one of the oldest public programs at SAIC. Formalized in 1951, with the establishment of an endowed fund by Flora Mayer Witkowsky, VAP features some of the most compelling practitioners and thinkers working today. Through a diverse mix of lectures, screenings, performances, conversations, and readings, VAP is one of the city's leading public forums for the presentation and contemplation of contemporary art, design, and scholarship.

Pictured at rear left is Chris Ware (who received a master of fine arts from the school in 1993), an award-winning cartoonist and author, during his term as the recipient of the Sick Distinguished Professorship in 2016, hosted by the print media department. Established in 2006 by a generous gift from William and Stephanie Sick, this distinguished professorship enables internationally renowned artists and designers to visit and teach at SAIC.

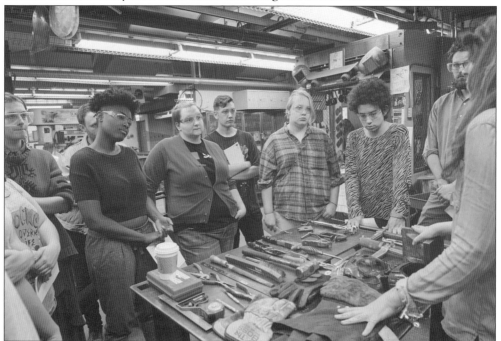

Students participate in a technical demonstration at the Columbus Drive metal shop. The role of students as learners and skills trainers around the school equipment is an important peer-to-peer mentoring system. Student employment offers an opportunity to develop interpersonal and communication skills while sharing technical knowledge.

George Roeder, a faculty member and founder of the department of visual and critical studies, celebrated the value of scholarship alongside artistic expression. He is seen here in 2004 as a participant in "Backgrounds and Conversations," a project by faculty member Adelheid Mers to map moral frameworks across the political spectrum based on George Lakoff's research. The students, faculty, and staff of SAIC are engaged and innovative creators of art, design, scholarship, and writing. The faculty drives the curriculum, and each member brings the diverse experiences of his or her practice directly into the classroom and studio. SAIC students are viewed as emerging peers and full participants in the learning that occurs in collaboration with faculty and each other. Through their diverse practices, the staff participates to support the learning process, promote the overall well-being, growth, and development of students, and enhance student success and the realization of students' full artistic potential.

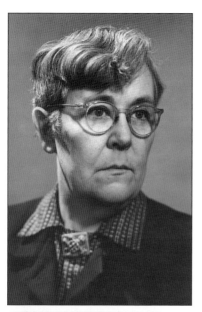

Kathleen Blackshear began her studies at SAIC in painting and graphic arts in 1924. Inspired by the art historian Helen Gardner, she developed a strong interest in art subjects outside the standard Western canon. With Gardner as a mentor and friend, Blackshear taught and studied art history, receiving her master's degree in 1940. Her teaching focused on the study of non-Western, pre-Renaissance, and progressive 20th-century art, and she is credited with having been a strong supporter of African American students, notably Margaret Burroughs.

This is a group portrait in the studio of Constantin Brancusi (left) with Tristan Tzara, an unidentified woman, the poet Mina Loy, Jane Heap, and Margaret Anderson. Heap studied painting and jewelry at SAIC beginning in 1901, and shortly after arriving in Chicago, she began writing and met Anderson; the two became lovers. They both associated with a group of independent young women in Chicago and New York, and from 1916 to 1926, Heap together with Anderson and Ezra Pound edited the celebrated groundbreaking literary magazine the *Little Review*, which established their position in the avant-garde and introduced literary modernism to North America. The review published an array of modern American, English, French, and Irish experimental writers. Controversially, in March 1918, it serialized the first publication of James Joyce's *Ulysses*. Following charges of obscenity, the Post Office Department seized and destroyed the first four issues. Heap and Anderson were convicted and fined but defiantly continued the serialization until 1921. (LC.)

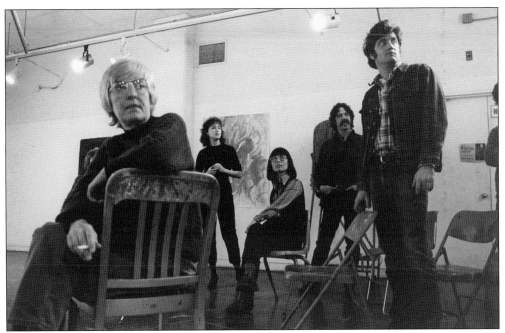

Seated are faculty members Betsy Rupprecht (left) and Michiko Itatani, and standing in the background is writer, performance artist, and teacher Guillermo Gómez-Peña. Both this and the following image show students and faculty participating in critiques and an ongoing commitment to critical discussion as a key teaching and learning strategy at the school.

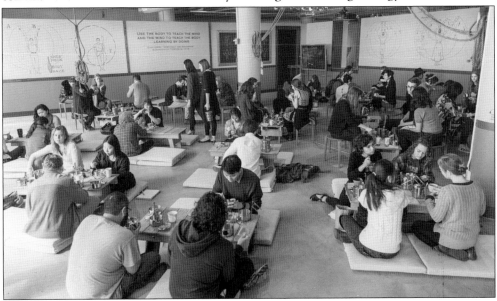

A lunch, convened during SAIC's 2014 "A Lived Practice" season in the Sullivan Galleries, was facilitated by artists Rirkrit Tiravanija (who received her master of fine arts in 1986) and Dan Peterman, with urban sustainability philosopher Ken Dunn. The lunch, offered to over 60 students and faculty members from SAIC and six other universities across Chicago, was an invitation through an embedded experience to explore and evaluate human and consumable resources in the urban environment.

"We Make History"

The school's major encyclopedic art museum, libraries, special collections, and public programs create an unparalleled environment for maintaining a thoughtful and tangible relationship to history. The ways in which it is continually revisited, represented, and fueling innovation and experimentation keep historical and critical discourse completely active. Students, faculty, and alumni of SAIC have made significant and groundbreaking contributions to the art, design, and scholarship of the 20th century and continue to do so in the 21st. Neysa McMein (who attended SAIC from 1907 to 1911) became one of the most renowned American illustrators of her era. Born Marjorie Frances McMein in 1888, she studied at both the School of the Art Institute of Chicago and the Art Students' League of New York before launching her career. During World War I, she directed her creativity toward painting posters and cartoons for the efforts abroad, commissioned by the American and French governments as well as the American Red Cross. She also traveled Europe to entertain the troops with writer Dorothy Parker. The US Marine Corps honored her with the title of a noncommissioned officer—an honor only two other women received. (NYT.)

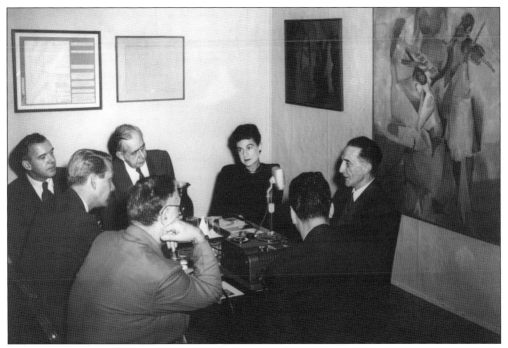

Marcel Duchamp is pictured being interviewed on October 19, 1949, by the press in the Duchamp room of the Arensberg exhibition at the Art Institute of Chicago. Note the wire recorder on the table in front of the artist. Clockwise from center are Katharine Kuh, Duchamp, Peter Pollack (the SAIC public relations counsel), Clarence J. Bulliet (the *Chicago Daily News*), Lou Spence (*Time* magazine), Ed Barry (the *Chicago Tribune*), and Cloyd Head (WMAQ Radio). Of the many influential women associated with the school and the museum, Kuh, a faculty member and curator, strongly advocated for the adoption of modernism in Chicago. As the director of a private Michigan Avenue gallery, Kuh stood by her passion for the modern, enduring protests and public outcries that resulted in the destruction of her storefront gallery windows. Then, as director of the galleries of interpretation at the Art Institute, Kuh devised groundbreaking didactic materials and pedagogical publications, collaborating with Ludwig Mies van der Rohe and László Moholy-Nagy to fulfill her aim of educating both the public and her students.

Nicholas Vachel Lindsay (1879–1931) studied at the school for three years, beginning in 1900. He is known as the founder of modern singing poetry, in which verses are meant to be sung or chanted. (SVCLL.)

William McKnight Farrow, the first African American instructor at the school, was best known for his draftsmanship and etchings. He attended SAIC from 1908 to 1917 and subsequently taught at the school from 1917 to 1945. He also supervised the school's print shop and was assistant curator of temporary and contemporary exhibitions in the museum. His position at the Art Institute of Chicago afforded him the opportunity to support and promote the work of African American artists, and he has been noted as a key influence upon many who were instrumental in the Harlem Renaissance.

Robert Neal (right) and Edgar Hellum are seen in front of Pendarvis, one of many buildings they restored in Mineral Point, Wisconsin. The two were students at SAIC between 1929 and 1932, and around this time, they became intimate partners and nearly lifelong creative collaborators. In 1934, they purchased and restored three 19th-century Cornish miners' cottages in Mineral Point and their creativity and energy spearheaded a revitalization of the architectural heritage and creative economy of the town. They initially made their living from the proceeds of a mail-order preserves business, and then through the success of a restaurant, Pendarvis House, that specialized in the preparation of traditional Cornish dishes. As the reputation of their work and kitchen grew, the town attracted an increasing number of artists and those seeking a more progressive lifestyle. Mineral Point thrives up to the present time as an inclusive community and a hub for arts, crafts, and fine foods. (MPA.)

"We Are Chicago"

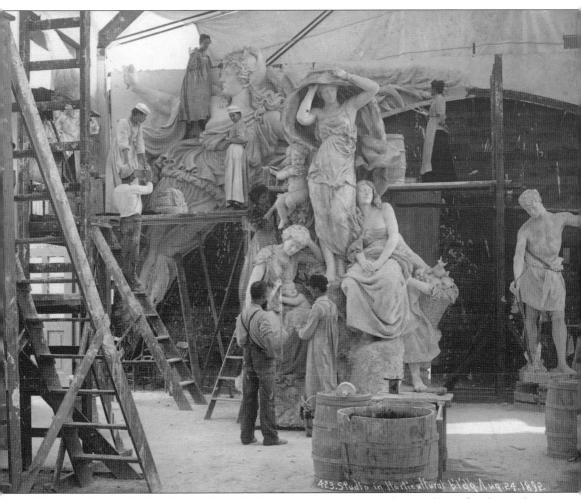

The school's symbiotic relationship with Chicago radiates outward as students, faculty, and staff connect themselves to the diverse communities of the city and the entire world. Forming a city within a city, a campus, close and yet not contiguous, the School of the Art Institute is urban. The city's richness, complexity, and contradictions are the perfect environment for SAIC's own diverse community. This photograph is dated August 24, 1892. In the foreground, Julia Bracken Wendt confers with Lorado Taft while working on sculptural ornamentations for the Horticultural building at the World's Columbian Exposition. Also shown in this picture are Bessie Potter Vonnoh and Carol Brooks MacNeil. A significant number of young sculptors began their working lives at the exposition. Taft, as an instructor of sculpture at SAIC, was in contact with many highly qualified women students, and he frequently employed female students as assistants on many of his projects. The women sculptors became known famously as the "White Rabbits." When Taft enquired of Daniel Burnham if he could employ women sculptors, Burnham is reputed to have replied, "Hire anyone, even white rabbits, if they can get the work done." (CHM, ICHi-02492.)

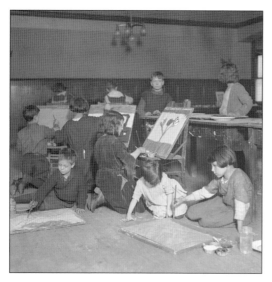

Enella Benedict (1858–1942) was born in Lake Forest, Illinois, and attended SAIC from 1886 to 1890. Benedict was influenced by realism and impressionism and painted portraits, landscapes, and scenes from daily life in oil and watercolor. In 1892, Benedict founded the art school at Jane Addams's settlement house, Hull House, located in a working-class neighborhood on the Near West Side. Benedict was dedicated to the belief that art could lead to social change. She taught art classes at Hull House while also teaching at SAIC. She organized an artist-in-residence program and provided artists the opportunity to exhibit their work. (CHM, DN-0076595; *Chicago Daily News*, photographer.)

The *Animal Court*, a collection of sculptures by Edgar Miller, was at the Jane Addams Homes, located at 1322 West Taylor Street in Chicago. Completed in 1937, this federal commission came to Miller on the recommendation of the architecture firm Holabird & Root, which led the design and construction. Miller studied at SAIC from 1916 to 1918 and taught ornament and interior decoration for two academic years, only 1923 and 1927. He was a remarkably prolific and multiskilled artist, working in paint, print, wood, glass, and ceramic. He is probably best known for his stained glass, which is included in scores of his public and private commissions. His work can be found throughout the Chicago region and as far afield as New York and Nebraska. (CHM, ICHi-37872; Kolin/*Chicago Herald Examiner*, photographer.)

Alumni Margaret-Taylor Burroughs received her bachelor of arts in 1946 and master of arts in art education in 1948. One of her greatest and best-known contributions to life in the city was that, at the age of 22 in 1940, she founded the South Side Community Arts Center. The center serves as gallery and workshop space dedicated to supporting African American artists. She later married Charles Burroughs, and together, in 1961, they founded the DuSable Museum of African American History, now located in Washington Park, Chicago. Her achievements include working as an artist in painting and sculpture, but it was in linoleum block printing where she displayed the most exceptional skill.

Pictured here are the founding members of the N.A.M.E. Gallery, originally located at the corner of Lake and Wells Streets in Chicago's Loop; from left to right are Nancy Davidson (who received her master of fine arts in 1975), Mary Ann King, Phil Berkman, Joanne Elam, Othello Anderson (bachelor of fine arts, 1973, master of fine arts, 1974), Carl Johnson (master of fine arts, 1973), Guy Whitney (bachelor of fine arts, 1974), Barry Holden, Christine Abiera (bachelor of fine arts, 1975), and Jerry Saltz. In 1973, a group of recent SAIC graduates, believing their work would never be shown in conventional art galleries, decided to create their own space to show experimental work and provide a platform for artists they saw as "genuine oddballs and visionaries" of their generation. N.A.M.E.'s early exhibitions drew crowds that numbered into the hundreds and included a mixture of performance, installation, film, and music. The gallery ran uninterrupted for more than 20 years.

DISCOVER THOUSANDS OF LOCAL HISTORY BOOKS
FEATURING MILLIONS OF VINTAGE IMAGES

Arcadia Publishing, the leading local history publisher in the United States, is committed to making history accessible and meaningful through publishing books that celebrate and preserve the heritage of America's people and places.

Find more books like this at
www.arcadiapublishing.com

Search for your hometown history, your old stomping grounds, and even your favorite sports team.